ANGELIC

visions

CREATE FANTASY ART ANGELS WITH WATERCOLOR, INK AND COLORED PENCIL

ANGELA R. SASSER

IMPACT
CINCINNATI, OHIO

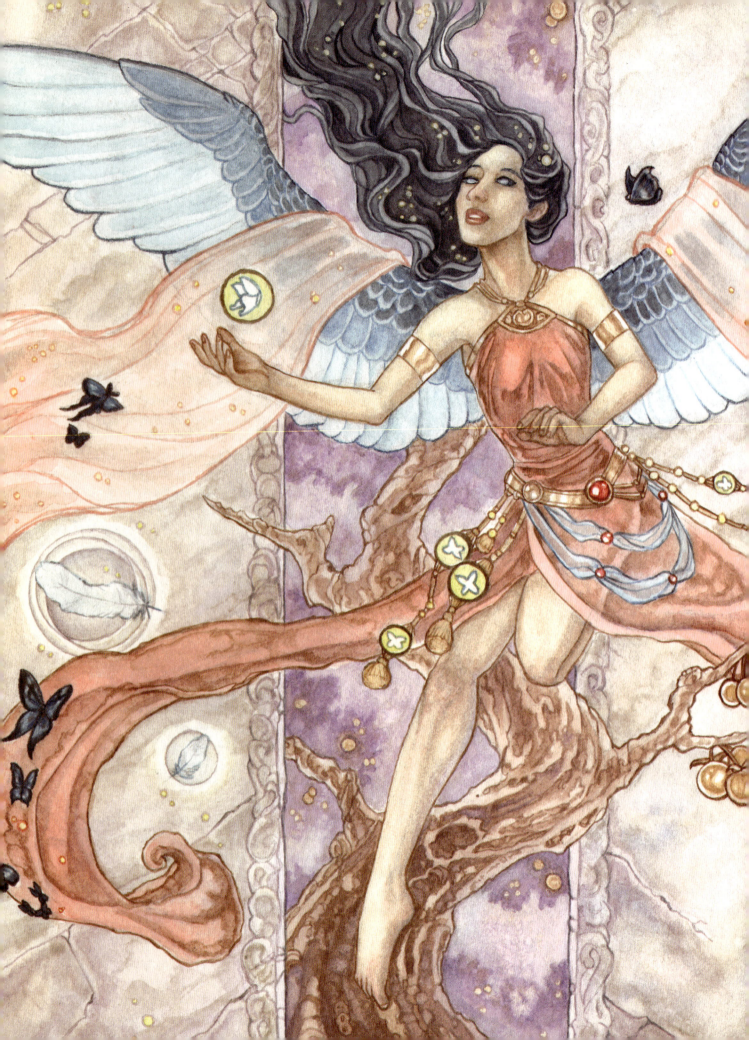

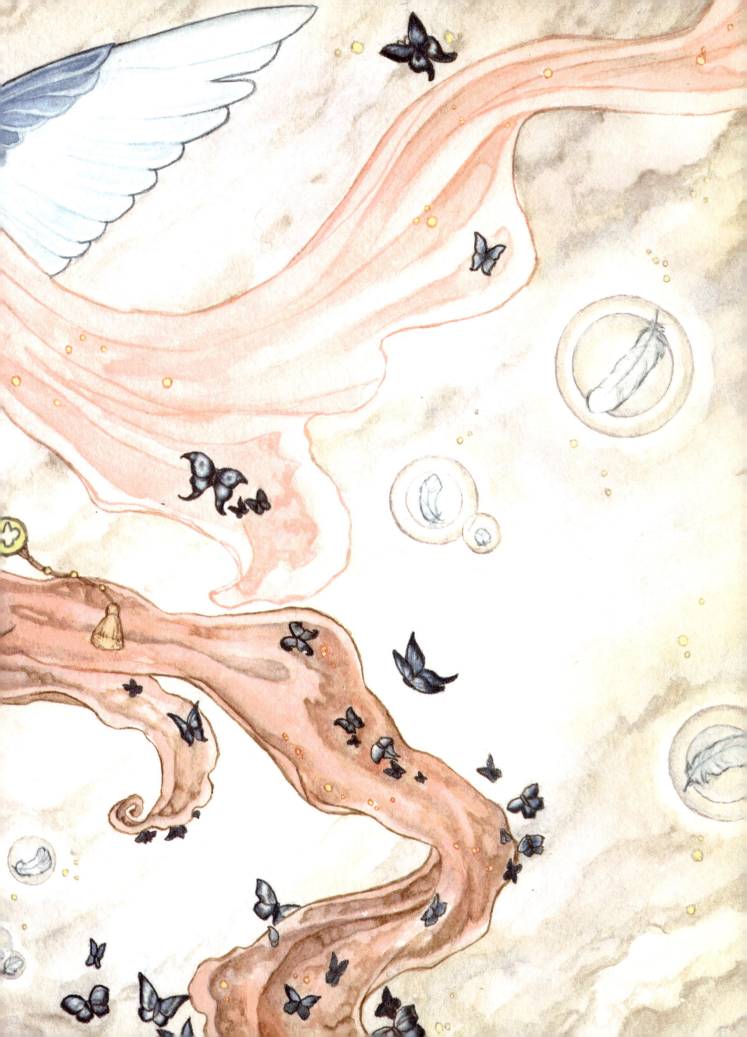

About the Author

Angela R. Sasser is a mythology junkie and fantasy illustrator based out of the Atlanta, Georgia area. She is a jack of all trades with interests ranging from creative writing to comics and video games. Her main love, however, is illustration.

She is greatly inspired by the romantic ideals of the Pre-Raphaelite masters and the decorative flair of the Art Nouveau movement. From Victorian decadence, the elegance of the oriental, or the ethereal nature of dreams and myths, she draws her art from a multitude of places.

Angela has earned bachelor's degrees in both English and studio art from the University of West Georgia, as well as a master's in arts administration from the Savannah College of Art and Design. Her work is generally found at convention art shows across the country, such as Dragon*Con, Anime Weekend Atlanta and other events throughout the United States. Her awards include 3rd Place in Color for her *Seasonal Angels* series at MileHiCon 40 in 2008 and Best Original at MOBI-CON 12 in 2009.

In her spare time, Angela enjoys reading fantasy epics, studying world mythology, and pursuing research for her list of endless projects and her own random amusement.

ANGELIC VISIONS: Create Fantasy Art Angels With Watercolor, Ink and Colored Pencil. Copyright © 2011 by Angela R. Sasser. Manufactured in China. All rights reserved. No part of this book may be reproduced in any form or by any electronic or mechanical means including information storage and retrieval systems without permission in writing from the publisher, except by a reviewer who may quote brief passages in a review. Published by IMPACT Books, an imprint of F+W Media, Inc., 4700 East Galbraith Road, Cincinnati, Ohio, 45236. (800) 289-0963. First Edition.

media

Other fine IMPACT Books are available from your local bookstore, art supply store or online. Visit the publisher at www.fwmedia.com.

15 14 13 12 11 5 4 3 2 1

DISTRIBUTED IN CANADA BY FRASER DIRECT
100 Armstrong Avenue
Georgetown, ON, Canada L7G 5S4
Tel: (905) 877-4411

DISTRIBUTED IN THE U.K. AND EUROPE BY F+W MEDIA INTERNATIONAL
Brunel House, Newton Abbot, Devon, TQ12 4PU, England
Tel: (+44) 1626 323200, Fax: (+44) 1626 323319
Email: postmaster@davidandcharles.co.uk

DISTRIBUTED IN AUSTRALIA BY CAPRICORN LINK
P.O. Box 704, S. Windsor NSW, 2756 Australia
Tel: (02) 4577-3555

METRIC CONVERSION CHART

To convert	to	multiply by
Inches	Centimeters	2.54
Centimeters	Inches	0.4
Feet	Centimeters	30.5
Centimeters	Feet	0.03
Yards	Meters	0.9
Meters	Yards	1.1

Library of Congress Cataloging in Publication Data
Sasser, Angela.
Angelic visions : create fantasy art angels with watercolor, ink and colored pencil / Angela Sasser. -- 1st ed.
 p. cm.
 Includes index.
 ISBN 978-1-60061-953-3 (alk. paper)
1. Angels in art. 2. Fantasy in art. 3. Watercolor painting --Technique. 4. Ink painting--Technique. 5. Colored pencil drawing--Technique. I. Title.
ND2365.S27 2011
743'.8864--dc22 2010024112

Edited by **Mary Burzlaff Bostic and Layne Vanover**
Production edited by Christina Richards
Designed by Clare Finney and Karla Baker
Production coordinated by Mark Griffin

dedication

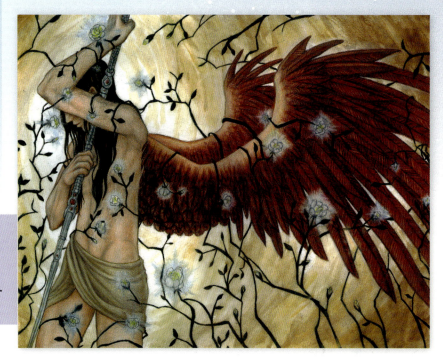

I would like to dedicate this book to my family: Mom, Dad and Roland. Without their support, love and encouragement, I would not be the person I am today.

To Sam, for always being there to light up the sleepless nights with encouragement, inspiration and helpful critique. To Kevin, Brenda, Hayley and both Stephanies for their quiet, unwavering faith in me.

To all the wonderful muses at deviantART.com who inspired me with their stock art and moral support: Lockstock, Fantasystock, Grinmirstock, Germanstock, Almudena-stock, Linzstock, Sitara-LeotaStock, and Pyrosaint-stox.

To all of you who ever picked up a pencil or a paintbrush and made a wish to be what others said you could not be.

Finally, to the fine folks at F+W Media who gave my dream a jump-start!

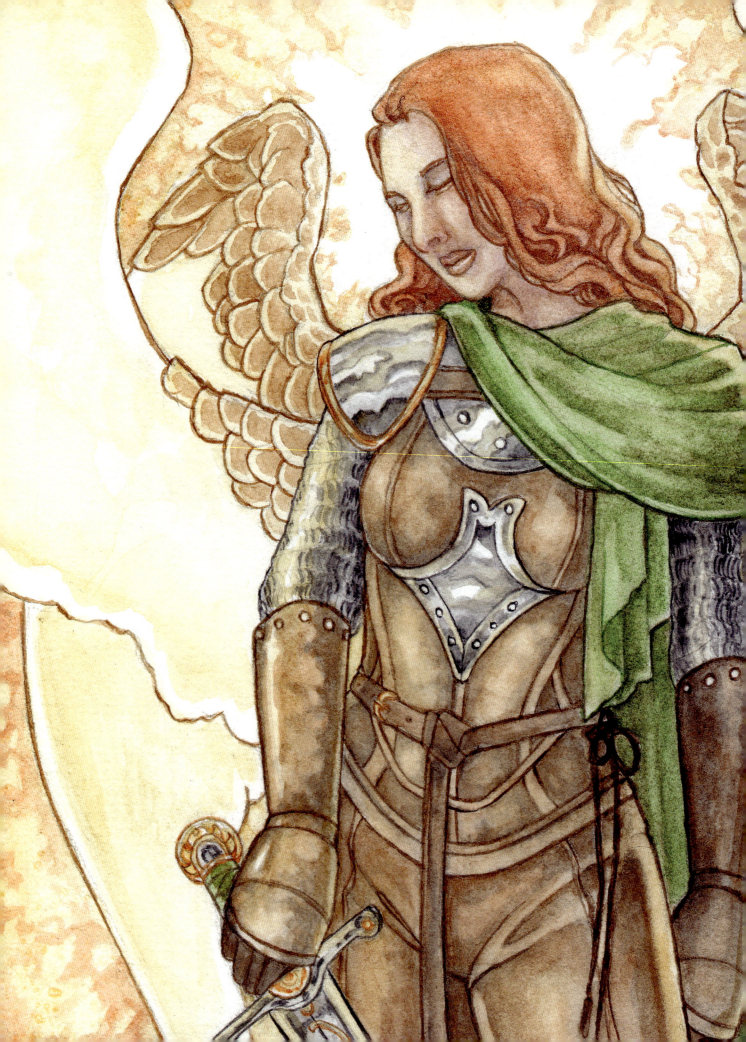

TABLE OF CONTENTS

INTRODUCTION 9

chapter one
MATERIALS AND TECHNIQUES 10

Watercolor • Watercolor Techniques • Colored Pencil • Colored Pencil Techniques • Pen and Ink • Pen and Ink Techniques • Other Important Techniques • Choosing and Preparing Paper • *demonstration:* Stretching Paper • *demonstration:* Transferring Images With a Grid • *demonstration:* Transferring Images With Graphite Paper

chapter two
DRAWING ANGELIC FIGURES 24

Finding Inspiration for Your Figures • Body Types • Facial Proportions • Facial Features • Hair • *demonstration:* Head, Front View • *demonstration:* Head, Three-Quarters View • *demonstration:* Head, Profile • Hands • Feet • Wings • Ornamental Wings • Non-Traditional Wings • *demonstration:* Drawing Gilded Wings • Skin Tones • Fabric and Clothing • Halos • *demonstration:* Creating an Implied Halo • Markings and Tattoos • *demonstration:* Painting a Tattooed Figure • Weaponry • Armor

chapter three
SETTING THE SCENE 56

Creating the Perfect Backdrop • Aerial Perspective • Linear Perspective • Clouds • Flowers • *demonstration:* Painting a Single Flower: Rose • *demonstration:* Drawing a Clustered Flower: Hydrangea • Stone Textures • *demonstration:* Suggesting Stone • *demonstration:* Depicting Stained Glass • *demonstration:* Angel of Purity

chapter four
CREATING ANGELIC VISIONS 74

Angelic Characters • *demonstration:* The Muses: Verdant Muse • *demonstration:* Muse of the Undiscovered • *demonstration:* The Guardians: Butterfly Guardian • *demonstration:* Valediction • *demonstration:* The Rebels: Night Blooming • *demonstration:* Unfurled • *demonstration:* The Archangels: Meditation on the Rose • *demonstration:* The Archangel of Death

INDEX 126

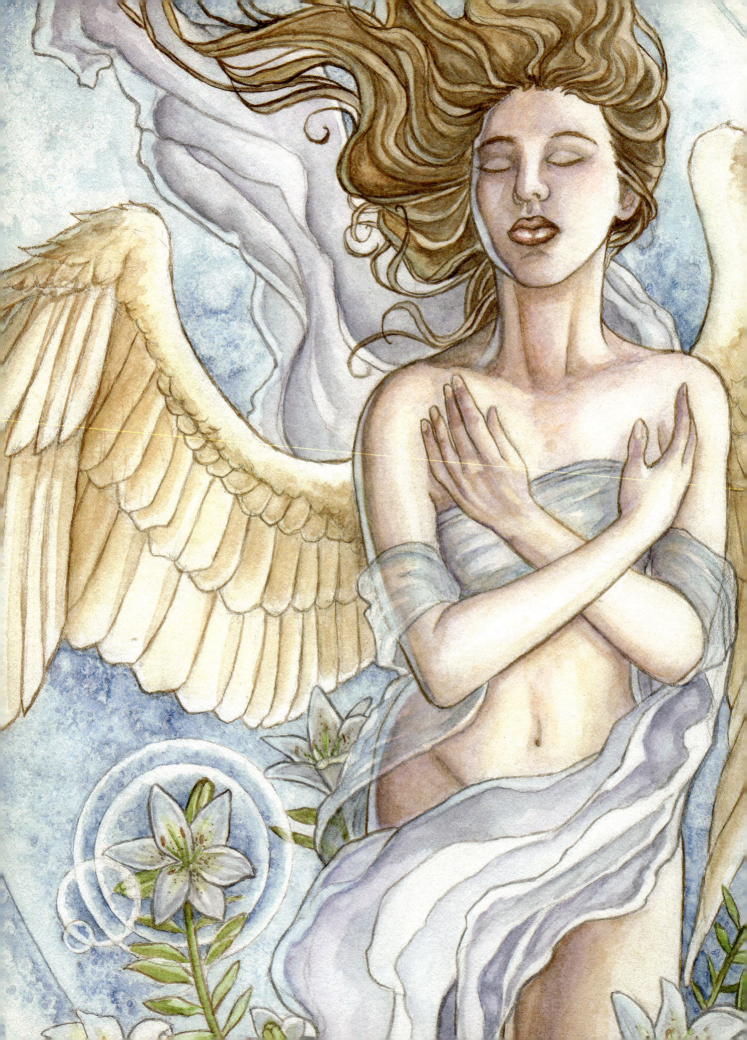

INTRODUCTION

what is an angel?

Is it a beautiful winged figure in a white robe strumming a harp? Is it a chubby baby with dove's wings flitting about a classical painting? Perhaps angels are beings of pure light carrying messages from the divine.

Angels have been many things to many people throughout the centuries, from emissaries of the divine to harbingers of holy wrath. These winged creatures have been a party to the stories of many cultures, Judeo-Christian, Greek, Roman, Persian and more. In modern times, the striking imagery of the winged figure has worked its way into our imaginations as a symbol of enduring beauty and power that is adaptable to stories of all types.

For the purposes of this book, angels are addressed as a universal visual symbol of inspiration. This book is not an academic source on angelic traditions or religious symbols, but instead is a guide for harnessing the tools of art to create your own interpretations.

Whatever angels mean to you, I hope this book will be a way to express that beauty in your own unique way.

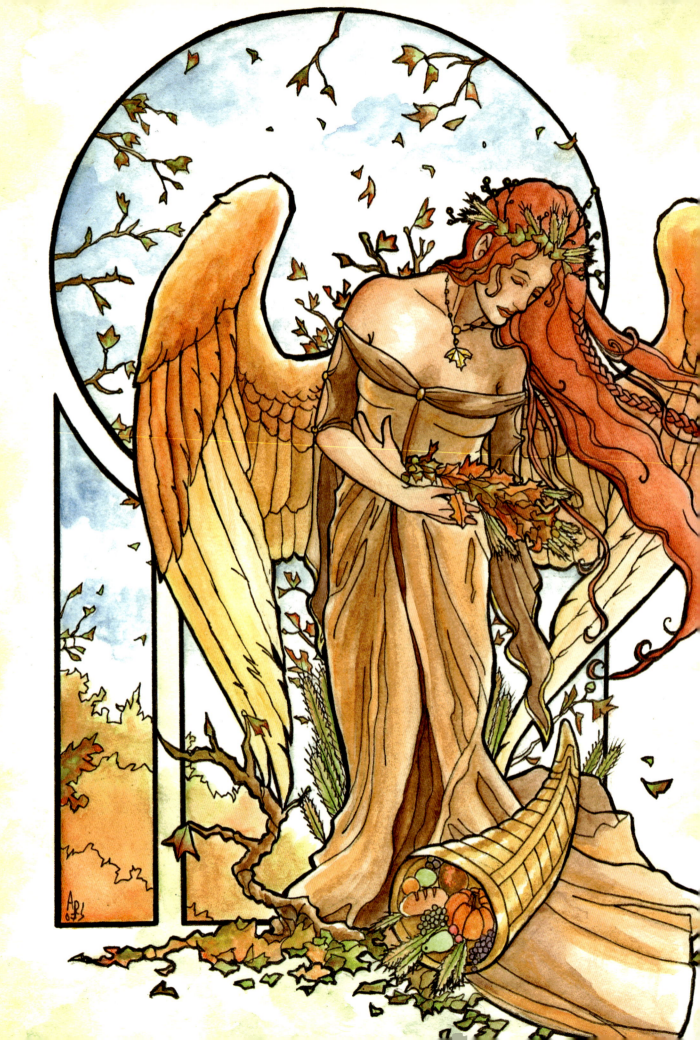

chapter one
MATERIALS AND TECHNIQUES

AS AN ASPIRING ARTIST, your first step is to familiarize yourself with the tools and techniques of the trade. This section serves to introduce you to a wide world of artist's instruments and methods that you'll use to create the compositions in this book.

Putting pencil to paper can certainly feel overwhelming at first, but with practice and experimentation, your confidence will grow. Likewise, it's important to remember to keep yourself open to possibilities. Within every pen, pencil or brush lies the potential to create something unique and exciting, so never limit yourself to one medium; experiment with them all to determine your preferences and develop your skills.

WATERCOLOR

Color shaper

Fan brush

Toothbrush

COMMON WATERCOLOR TOOLS

Watercolor is a wonderful medium for any artist, beginner or professional. It is known for its translucency and luminosity and is widely available in tube or pan form at a relatively inexpensive price. Unlike some other types of paint, watercolor is water soluble and doesn't require the use of turpentine or other solvents.

BRUSHES

Watercolor brushes are available in numerous sizes and shapes, including round, flat, chisel and fan. To start out, you'll need a decent range of basic round brushes and a flat brush for creating washes. In addition, you might want to use a rubber-tipped color shaper to push or pull the paint while it's wet or to apply masking fluid.

The mark of a quality brush—whether sable or synthetic—is that it keeps the shape of its tip after prolonged use. Remember, investing in a quality brush up front pays off later.

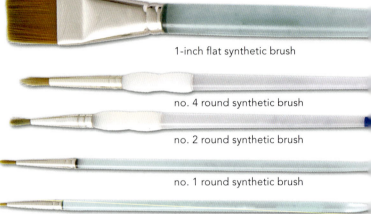

1-inch flat synthetic brush

no. 4 round synthetic brush

no. 2 round synthetic brush

no. 1 round synthetic brush

no. 10/00 round synthetic brush

ESSENTIAL WATERCOLOR BRUSHES

PAINTS AND PALETTES

Technically, you can create any color from the three primary colors. However, you may want to buy additional paints to avoid the fuss of mixing colors from scratch each time you paint.

QUALITIES OF COLOR

Some watercolor pigments are less prone to fading than others. This quality is called *lightfastness* and is indicated by a number on the tube— 8 (or I) being the highest lightfastness (the most fade resistant) and 1 (or IV) being the lowest. Colors with low lightfastness are called *fugitive colors.*

Additionally, some watercolor pigments, such as Naples Yellow, Yellow Ochre, Cerulean Blue, Chinese White and many of the cadmium hues, are slightly more opaque than others. Such colors can be mixed with other pigments to create a more opaque look, or thinned down with water to become more transparent. Test your pigments before you begin painting to get a feel for how they'll look when completely dry. Similar hues also vary by brand, some pigments being more pure than others based on the quality and grade of the particular brand. This makes it all the more important to test your colors out before using them in a painting.

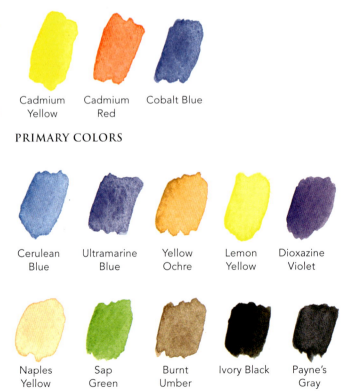

Cadmium Yellow Cadmium Red Cobalt Blue

PRIMARY COLORS

Cerulean Blue Ultramarine Blue Yellow Ochre Lemon Yellow Dioxazine Violet

Naples Yellow Sap Green Burnt Umber Ivory Black Payne's Gray

SAMPLE COLORS FOR YOUR PALETTE

WATERCOLOR TECHNIQUES

1 SCRAPING

Scraping creates textured highlights that are especially effective for highlighted reflections on the surface of water or rough metals. Use a craft knife, your fingernail or any kind of edge to scrape paint from the surface of thick paper. Avoid scraping all the way through the paper.

2 DRYBRUSHING

To create dry-brush texture, load a brush with pigment, dab it on a paper towel, then drag it along the surface. The strokes will show more of the paper texture and the hairs of the brush. With more water, the strokes become more dense and solid. Drybrushing is useful for creating rocks, feathers, hair and other rough surfaces.

3 WET-INTO-WET

Saturate your paper with water, then drip paint onto the surface and watch the colors bloom and mingle to form stars and organic shapes useful for stone, skies and other soft patterns. Drop water on top of the paint to spread it around, creating even more interesting shapes.

4 SALT TEXTURE

Toss a pinch of table salt onto wet pigment to create a crystal starburst effect. Once dry, wipe the salt away. (I use a soft bristled brush stiff enough to move the crystals, but not hard enough to scratch the paper.) Layering different colors in this way can be used to create weathered stone, starry skies or mottled forest lighting. Don't use a hair dryer or salt may meld to the paper permanently!

5 RUBBING ALCOHOL

Splatter rubbing alcohol with a toothbrush or dab it on with a brush while the pigment is still wet to create bubbles in the color. This can be useful for underwater bubble effects, dappled lighting or cloudy skies.

6 PLASTIC WRAP

Lay plastic wrap in wet pigment, allow it to dry, then remove it to create an organic texture. This can be used for creating rocks, mottled lighting and stained glass.

7 LIFTING

Apply a wet brush or paper towel to any color to lift the pigment, revealing the white beneath or a layer of color that is dry and harder to lift. The longer you leave water on top of the color, the more pigment you'll lift out. Lifting can alleviate some mistakes and works best while the paint is still damp. Some colors, like blues, are easier to lift than others. Try lifting with different tools, like cotton swabs or sponges, to create a variety of color transitions and textures.

8 SPONGE

Natural sponges are better for creating random texture, while man-made sponges are good for a more ordered pattern. Use this technique combined with others for dappled lighting, weathered stone and skies.

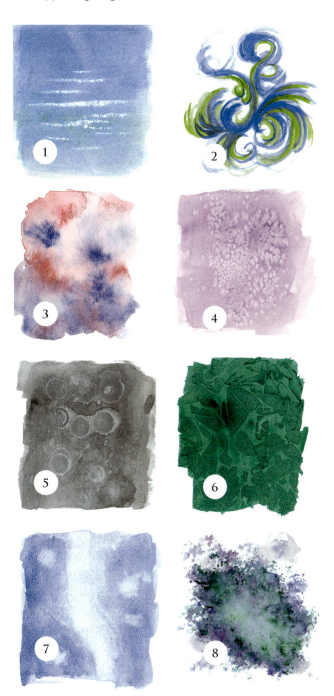

COLORED PENCIL

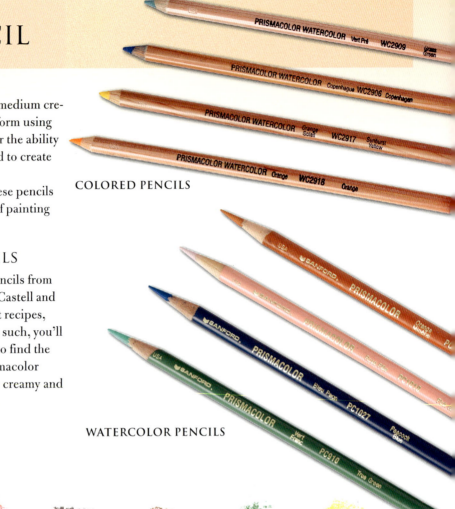

Colored pencils are a versatile semi-opaque medium created by binding various pigments into stick form using wax and other special ingredients. They offer the ability to create many controllable areas of color and to create subtle shifts in color.

Another option is watercolor pencils. These pencils are water soluble and can mimic the effects of painting with watercolor.

COLORED PENCILS

BRANDS OF COLORED PENCILS

There are many brands of quality colored pencils from which to choose, including Derwent, Faber-Castell and Prang. Because different brands use different recipes, they may behave uniquely when blended. As such, you'll want to experiment with a variety of brands to find the one that suits you best. I personally use Prismacolor colored pencils, because I find the colors are creamy and have exceptionally smooth blending quality.

WATERCOLOR PENCILS

| Black | Indigo Blue | Crimson Red | Dark Umber | Sienna Brown | Grass Green | Canary Yellow |

SUGGESTED STARTER PALETTE

| Light Peach | Peach | Beige | Light Umber | Blush Pink | Rosy Beige |

ADDITIONAL SKIN COLOR PALETTE

Colored Pencil Techniques

The ability of colored pencils to create shifts of subtle color with a variation of texture and smoothness makes them extremely versatile tools. Experiment with various types of shading to achieve interesting variations of color and texture in your images.

Blending Color

To successfully blend with colored pencils, build up many light layers of color, keeping in mind the subtle tones within a single color. For smoother shading, keep your pencils sharp and vary the directions of the strokes to insure that you cover the paper completely. The more layers, the smoother the shading becomes.

BASIC LAYERING
Create basic layers with colored pencils by lightly applying one layer on top of another.

BLENDING WITH CLEAR MARKER BLENDER
Clear marker blenders break down the pigment in colored pencils, allowing you to spread and smooth them out while eliminating some of the natural texture.

BLENDING WITH COLORLESS BLENDER
This is the pencil version of the clear marker blender, but it does not break down pigment as harshly. It's useful for smoothing texture out of darker colors without smearing or ruining them.

Burnishing

To smooth out layers and shading, try applying a layer of White on top of the previous colors. Applying a bit of pressure will help you control the direction in which the color smooths out. You can also try using Cool Grey 10%, Cloud Blue, Light Peach and Beige.

Adding Water to a Color Application

Colored pencils have a degree of solubility that allows you to spread the color out somewhat with water, while watercolor pencils can be broken down completely with water. However, you don't have to use water with watercolor pencils—you may choose to blend as if they were regular colored pencils.

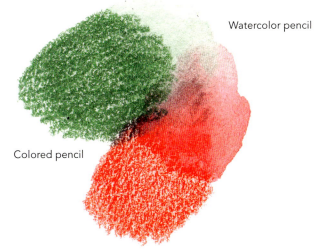

Watercolor pencil

Colored pencil

ADDING WATER TO COLORED PENCILS
Regular colored pencils will break down somewhat with water, while watercolor pencils will completely dissolve.

Sienna Brown + White

Sienna Brown + Cool Grey 10%

Sienna Brown + Cloud Blue

Sienna Brown + Light Peach

Sienna Brown + Beige

BURNISHING
By burnishing, you can make the initial color cooler or warmer, depending on what color you burnish with.

OTHER IMPORTANT TECHNIQUES

APPLYING A WASH

Washes are one of the most basic and frequently used techniques in watercolor painting. They are useful for making backgrounds and skylines and for laying in base colors.

To ensure an even layer of color, first wet the paper thoroughly. Then, using a flat brush, lay down slightly overlapping strips of color. If your paper is appropriately wet, these strips will then bleed together, creating a flat area of consistent color called a *flat wash*. If you find that your color isn't spreading well, just add more water. Don't worry about going back and correcting small inconsistencies—these have a way of smoothing out as the paper dries.

Similarly, you can lay in what is known as a *graded wash*, or a wash that has a subtle gradient from light to dark, or from one color to another. Darker, richer tones are created by layering the same color on top of itself multiple times.

GLAZING

FLAT WASH

GRADED WASH

A *glaze* is a slightly diluted wash of color, either straight from the tube or a mix of other colors, that is applied in thin layers to your format. Layering many thin glazes and letting them dry between each application can create an intensity of color not achievable through simply applying one single layer of saturated color. Because the layers are also translucent, the underlying layers show through and blend optically, allowing heightened luminosity of your colors.

If the preceding color is still too intense, layer more glazes on top to blend and balance your colors properly. Some of the colors are more opaque than others and need to be diluted more to create a translucent glaze. Always do a color test with your pigments (similar to the chart below), to get an idea of what colors will look like when glazed with other colors.

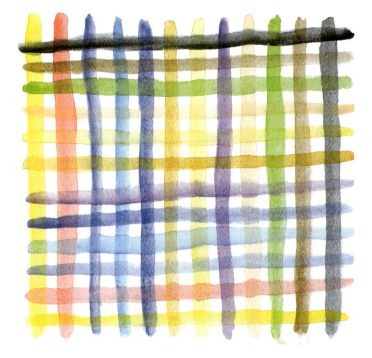

GLAZES

Notice how different each color looks after it has been covered with a glaze. To create more neutral tones, layer complementary colors, or colors which are opposite to one another on the color wheel. Creating a color intensity chart such as this one will help you learn how the colors interact.

MIXING MEDIA

There are some who may scoff at mixing media, calling it an "impure" art form, but this label is rapidly dwindling as experimental art grows in popularity. I prefer to combine media because it allows me to have the best of all worlds, from the ethereal luminosity of watercolor to the subtle textures and striking contrast of colored pencil and inks. Each medium can create particular effects more easily than others. You won't figure out these qualities without experimentation. My suggestion: Do what you love. Experiment and find what works best for you. Why stick to one medium when you can have them all?

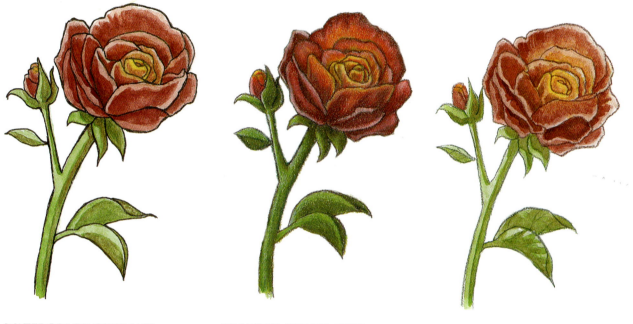

WATERCOLOR OVER INK

Applying watercolor over ink sketching can create a stained glass effect, or, when paired with hatching and ink shading, can create an image with very dramatic lights and darks.

Use archival or waterproof inks to avoid bleeding. Also try using various colored inks for interesting effects. Opaque watercolors may lighten the ink lines, so they might need to be redrawn. Also keep in mind that it is more difficult to create straight lines on textured paper, so consider using a paper with minimal tooth when utilizing this method.

COLORED PENCIL OVER WATERCOLOR

A base layer of watercolor beneath colored pencil layers results in a smooth, blended effect, with subtle color shifts created by the paper's texture. Normally, the texture showing through the watercolor would be white, but because there is a layer of watercolor beneath it, the subtle undertones will show.

Layering colored pencil over watercolor has a softer effect than ink over watercolor, but it creates a more dramatic play of shadow and light than painting watercolor over colored pencil.

WATERCOLOR OVER COLORED PENCIL

Applying watercolor over colored pencil creates a lighter, more ethereal mood. Colored pencil can add areas of contrast, fine detail and texture that are not as easy to achieve with watercolor alone. Colored pencils also work wonderfully as an outline since they fade minimally with successive washes of water. Try using a smoother surface so that the paper's tooth does not show through the colored pencil too much.

Choosing and Preparing Paper

Choosing the correct paper for the media you are using can enhance your artwork and prevent many mishaps. When shopping for watercolor paper, you'll notice that the paper is generally defined by two key elements: texture and weight.

Texture

A paper's texture refers to the grain or *tooth* of its surface. The three main categories of texture used by artists are rough, cold-pressed and hot-pressed.

ROUGH: This paper is extremely textured with the most prominent tooth. Washes of paint tend to pool in the recesses of the texture, while quick, dry-brushed strokes will stick to the peaks of the paper tooth, creating a heavily textured effect. This paper is best for a more expressive style of painting and is not well suited to tight detail.

COLD-PRESSED: This paper has a moderate tooth and is more suited to fine detail. Cold-pressed paper is commonly used for watercolors because its absorbency and texture is favorable to color vibrancy. It is recommended for beginners because paint is more easily controlled on a cold-pressed surface.

HOT-PRESSED: This paper has a smooth surface with very little tooth. It is more commonly used for opaque paints, colored pencils and inks, which are easier to apply to smoother surfaces. It works well for fine detail and even washes of color, though colors may tend to slide around on the smooth surface.

Weight

Paper weight is measured in pounds per ream (lb.) or grams per square meter (gsm). The greater the weight, the thicker the paper. Paper that is less than 260 pounds (356gsm) generally needs to be stretched so it can take water without buckling or warping (see the paper-stretching demonstration for instructions).

Alternatives to Watercolor Paper

Illustration board is a great alternative to watercolor paper. Much like watercolor paper, it is available in various surface textures. However, illustration board is layered with a heavyweight backing that keeps it from warping, which means you don't have to worry about stretching it!

I personally use Strathmore 500 Series Illustration Board, as it is double-sided and I can paint on the front or the back. Experiment with numerous brands to find your best fit.

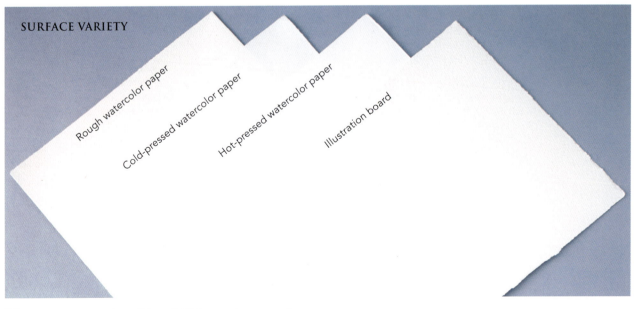

SURFACE VARIETY

Rough watercolor paper

Cold-pressed watercolor paper

Hot-pressed watercolor paper

Illustration board

demonstration:
STRETCHING PAPER

While heavier paper and illustration board can withstand the abuses of heavy washes and water, paper that weighs less than 260 pounds (356gsm) must be stretched before you begin painting. Otherwise, your paper will warp and buckle when water is applied, ruining even your best efforts.

It might sound like a monumental task, but don't fret! Stretching your paper is as easy as gathering a few basic supplies and following these four simple steps.

MATERIALS

Acid-free masking tape

Masonite board

Plastic tray or bowl of water

Sponge or paper towel

Watercolor paper

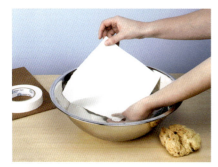

1 Wet the Paper
Soak the sheet of paper in water until it is thoroughly wet. Thicker paper will take longer to absorb water.

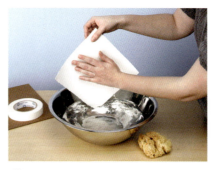

2 Remove Excess Water
Remove the paper from the water and let the excess drip off, running your hands along the paper to speed the process.

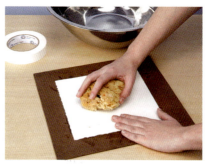

3 Position the Paper
Center your paper on a Masonite board and dab the excess water off with a sponge or paper towel, wiping up all the bubbles so the paper lays completely flat.

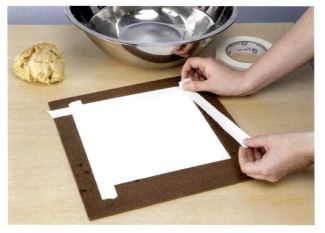

4 Tape the Edges
Stretch the paper, taping the edges to the Masonite board using acid-free masking tape. Once your paper has completely dried, it's ready to use!

MASONITE AND MASKING TAPE ALTERNATIVES

Masonite board is a hard surface, which is handy for keeping your paintings flat. Attaching a painting to Masonite also makes it portable, whereas a painting attached to a table or desk would have to stay put until completed. Yet another advantage to using Masonite board is you can have it custom cut to the size of your choice at most hardware stores. However, if Masonite isn't an option for you, feel free to use any hard surface of your choice.

Acid-free masking tape works for smaller paintings, but it's not strong enough to keep larger paintings flat. If you will be painting larger than 11" × 14" (28cm × 36cm), try gummed paper tape, which becomes sticky when wet and has a stronger hold than masking tape.

demonstration:
TRANSFERRING IMAGES WITH A GRID

The grid method is a simple, traditional way to transfer drawings to your painting surface accurately. A grid allows you to concentrate on tiny sections without becoming distracted by the figure as a whole. Remember: Always draw lightly so you won't ruin the surface of the watercolor paper when it's time to erase the grid lines.

MATERIALS

Eraser

Original image to be enlarged

Pencil

Ruler

Sheet of plastic transparency (or image-editing program where you can create a grid)

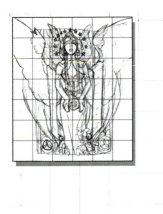

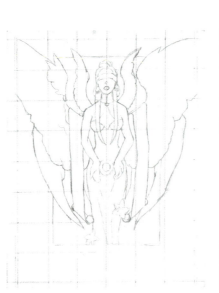

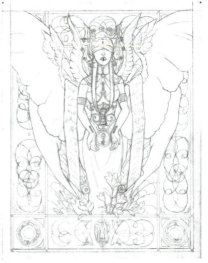

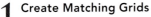

1 Create Matching Grids
Draw a grid on the image you wish to transfer, then draw a grid of the same height and width proportions on your painting surface.

If you have a computer, you can draw a grid across your image digitally. Likewise, if you don't want to draw on your image, simply draw a grid on a piece of plastic transparency to place over your image.

2 Map Out the Image
Using the gridded image as a reference, begin drawing the image on your painting surface. Concentrate on transferring the basic shapes before concerning yourself with the details. Keep it simple and transfer from square to square.

3 Complete the Sketch
Now that you have the basic figure blocked in, erase the grid lines and lay in the final detail. I recommend doing final detail after erasing the grid lines so you won't have to interrupt your shading or detail by erasing the grid line from it.

demonstration:
TRANSFERRING IMAGES WITH GRAPHITE PAPER

If saving time is of the essence, then transferring images with graphite paper is definitely the way to go. What's more, graphite paper is reusable, which means you also save on supplies. However, to avoid damaging your original image, I suggest making a printout on the computer to trace instead.

Though this is my preferred method of transferring images, there is one notable drawback to using this technique—because you are tracing, the image you are transferring must be the same size as your drawing surface. So, if you want to make your image larger or smaller, the grid method is a better choice.

MATERIALS

Acid-free masking tape

Drawing surface

Drawing to be transferred

Graphite paper

Mechanical pencil or pen

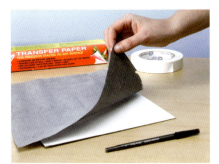

1 Prepare the Graphite Paper
Cut a piece of graphite paper large enough to cover the area of the image you wish to transfer. Place the graphite paper chalky side down on the drawing surface and secure the edges together with acid-free masking tape.

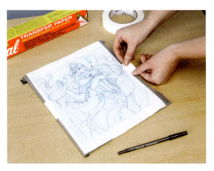

2 Place the Image on Top
Place the image you wish to transfer on top of the graphite paper so the transfer paper is sandwiched between the image and the drawing surface. Secure the image on top with more tape.

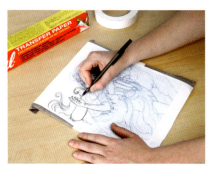

3 Trace the Image
Now that the image is securely in place, trace the lines of the drawing. Press firmly with a mechanical pencil or pen so the pressure will go through the layers and the graphite will transfer to the drawing surface.

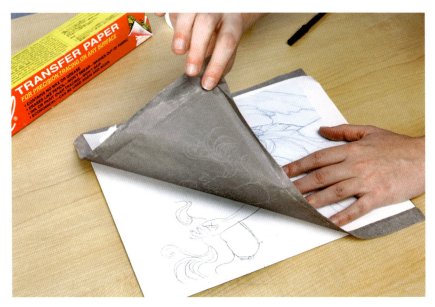

4 Check the Transfer
Once you are finished tracing, lift up one corner of the paper and graphite sheet to make sure the image transferred properly. If it has, remove the transfer paper and reference image.

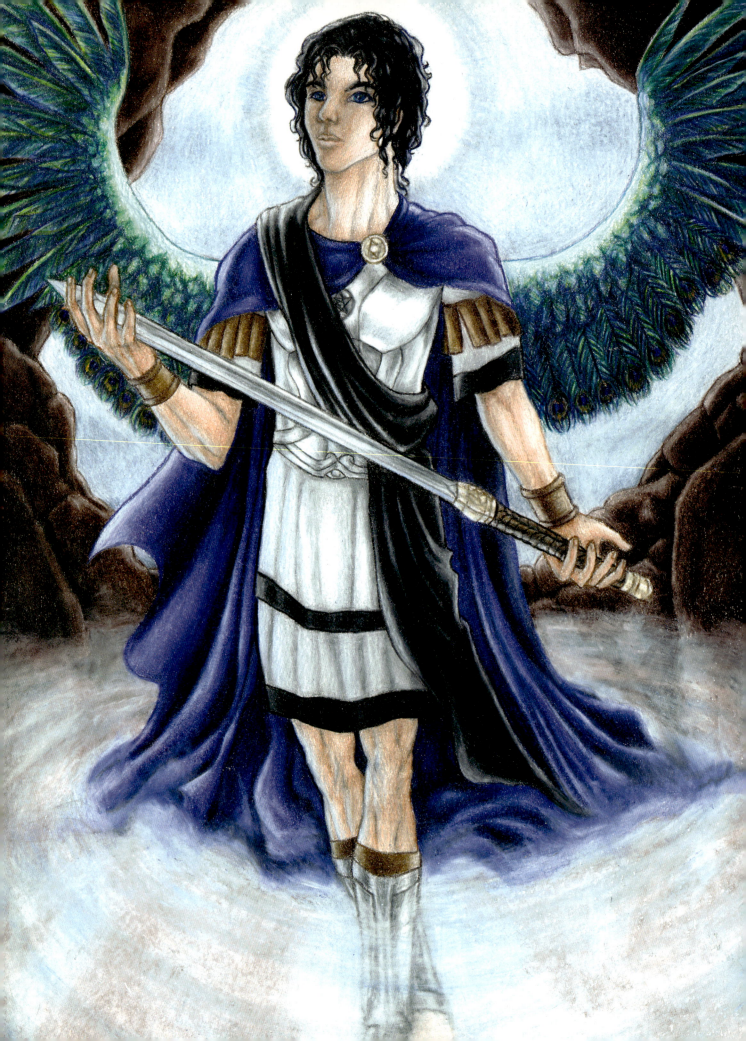

chapter two

DRAWING ANGELIC FIGURES

NOW THAT YOU'VE HAD A CHANCE TO

experiment with your media and materials, it's time to venture into the realm of character creation! This next chapter covers some of the basics of figure drawing, depicting realistic skin, and arming your angels for their grand adventures.

However, do not tread lightly into the world of character design without bearing this knowledge in mind: A pretty face does not always equal a good character! A gorgeous image will fall flat if it does not engage a viewer in some way, either through your angel's interaction with his or her setting, interaction with the viewer, or the visual interest created by the angel's design and compositional framing. Always ask yourself why? Why is my angel here? What purpose does he or she have in the universe? Why is he or she floating in space, looking pretty? What is the angel's connection to the other elements in your painting?

This book is far too small to encompass all of the intricacies of character creation and design so I encourage you to read, read and read more! Books on concept art, particularly ones made for fantasy movies, are great sources of knowledge and inspiration not only for character creation and design, but for learning how they relate to the over-arching themes of your paintings and the stories they tell.

FINDING INSPIRATION FOR YOUR FIGURES

ANGELS IN ART

Finding angelic inspiration is as easy as taking a jaunt to the nearest library. Angels have been present in art for many centuries, dipping their wings in countless eras as symbols of beauty, strength and divinity. However, you will find angels featured most prominently in medieval, Renaissance and Pre-Raphaelite art, where they are depicted as divine messengers, muses and warriors. My personal inspirations include the art of John William Waterhouse, Sir Edward Burne-Jones, Alphonse Mucha and John Melhuish Strudwick.

Bringing angels to life is a matter of drawing on your own sense of what is beautiful, powerful and ready to take flight with your imagination. Most angels are depicted with wings, but you will learn that they are not limited to this stereotype and are unbound by convention.

ANGELIC FIGURES IN MYTHOLOGY

It's worth noting that angels as winged divine figures are not merely confined to Christian art and literature, but are also present in Greek, Persian and Roman art and mythology. Cupid, or Eros, in his cherub or adult form, is one of the more familiar Greco-Roman figures, but there is also Iris, the goddess of the rainbow, and Aurora, the goddess of dawn. You might spot Nike, the winged Greek goddess of victory, on vases and murals, inspiring heroes towards great deeds.

ANGELS IN SCULPTURE

Finding inspiration need not be limited to studying only paintings of angels. There's a whole world of striking sculptures of angels and winged beings. Through sculpture, we can experience even further the effect and physical presence of these awesome beings, particularly the weight and expression of their wings. Wings flared in victory, mantled majestically or softened in an embrace are some of the qualities expressed in sculpture. Some of my personal favorite sculptors who have depicted angels include Michelangelo, Bernini and Rodin.

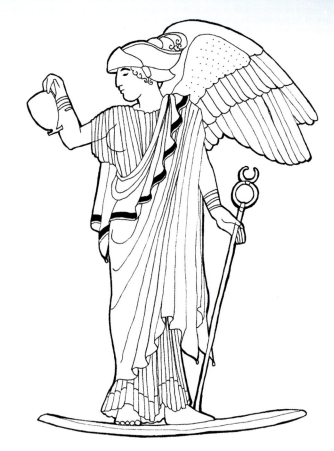

IRIS, GODDESS OF THE RAINBOW
Iris, goddess of the rainbow, represents one of the many non-traditional angelic figures you can draw inspiration from.

FINDING ANGELIC SCULPTURES

If you are unable to travel to an art museum, you may be able to find inspirational sculptures at the nearest cemetery. Angels are often present on sepulchers as protective figures and are found in historical cemeteries.

ADDITIONAL INSPIRATION

You might also find inspiration at zoos or parks, where you can observe a variety of winged creatures. Swans, in particular, make great reference for angel wings. Also, gardens during springtime are wonderful places to find references and inspiration for flowers and colors.

KEEPING A SKETCHBOOK

Whenever you visit a museum or cemetery, have your sketchbook with you should the muse strike. It's also helpful to make some studies of wings and other complicated subjects. Always check with the museum to see if it's OK to sketch or photograph the works of art.

AVOIDING PLAGIARISM

When you can, it's always handy to sketch or photograph your own references. However, you can also find references for wings, figures and just about anything else you might need on the Internet for free use, but only if you intend to study these images to gain ideas. Be aware that some images are not free to use if you intend to copy a reference directly. You must check with the owner of the image before you use it for your own purposes. Also, never copy the work of another artist without first asking their permission, even if you only intend to copy for educational purposes. Old Masters' images are, for the most part, in the public domain and are free for educational use. When in doubt, always ask the owner of any image.

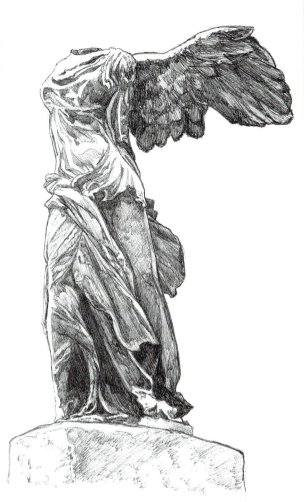

WINGED VICTORY ON DISPLAY AT THE LOUVRE

An ink sketch of Nike of Samothrace on display at the Louvre. Notice how expressive her body and wings are! The spread of her wings and flow of the cloth about her form add a sense of grace and power characteristic of Greek and Roman sculpture, which are excellent sources of inspiration.

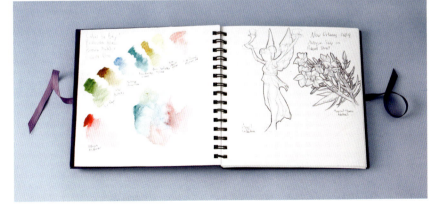

SUGGESTED READING

- *Angels and Demons in Art* by Rosa Giorgi
- *Angels: Celestial Spirits in Legend & Art* by Jacqueline Carey
- *Dictionary of Angels; Including the Fallen Angels* by Gustav Davidson

SELECTING A SKETCHBOOK

A small sketchbook like this one is easy to take with you anywhere. Don't be caught unawares by inspiration!

Body Types

An easy way to begin building your angelic character is to think about the type of presence they have. Is he an imposing muscular warrior? A gentle feminine soul? Or a mischievous little sprite? Think about how you can relay these traits with your character's physical presence.

Average

The average figure for a normal individual is around 7 heads tall. This proportion is most commonly used for portraying angels and spirits who are closer to human proportions.

Tall

Figures that are 8 heads tall are bold and larger than life, suggesting power, protectiveness and strength, particularly if the tall figure is muscular. If you prefer a more ethereal figure, use elongated limbs and exaggerated bone structure to suggest a more ghostly presence.

Figures at 8 heads tall are the common proportions for super-human characters in comic books.

Childlike

A diminutive structure at 3 heads tall with a larger head and larger eyes suggests childlike innocence. This stature is useful for portraying cherubs and other helpful attendant spirits.

Tiny

These figures are the smallest at around 1 head length in height. But this doesn't mean we should underestimate them. Tiny angels are said to sanctify every strand of grass and to exist in all things, large or small. Drawing angels at this stature suggests a more unearthly presence that often blesses us when, and where, we least expect it.

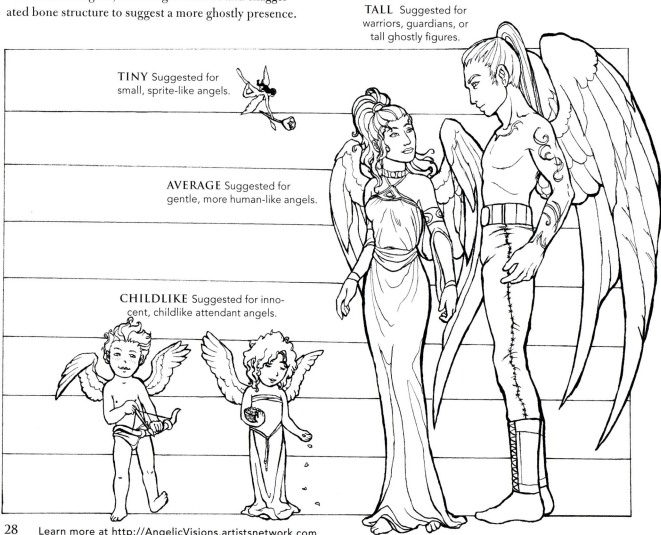

TALL Suggested for warriors, guardians, or tall ghostly figures.

TINY Suggested for small, sprite-like angels.

AVERAGE Suggested for gentle, more human-like angels.

CHILDLIKE Suggested for innocent, childlike attendant angels.

ANGELIC BUILDS

The physical appearance of angels can be as varied as your imagination. Classical angelic figures from Renaissance works are robust, with muscular features. Still other angels appear as effeminate beings, with an undefined gender. Study and experiment with these features to find what types match your vision of angels.

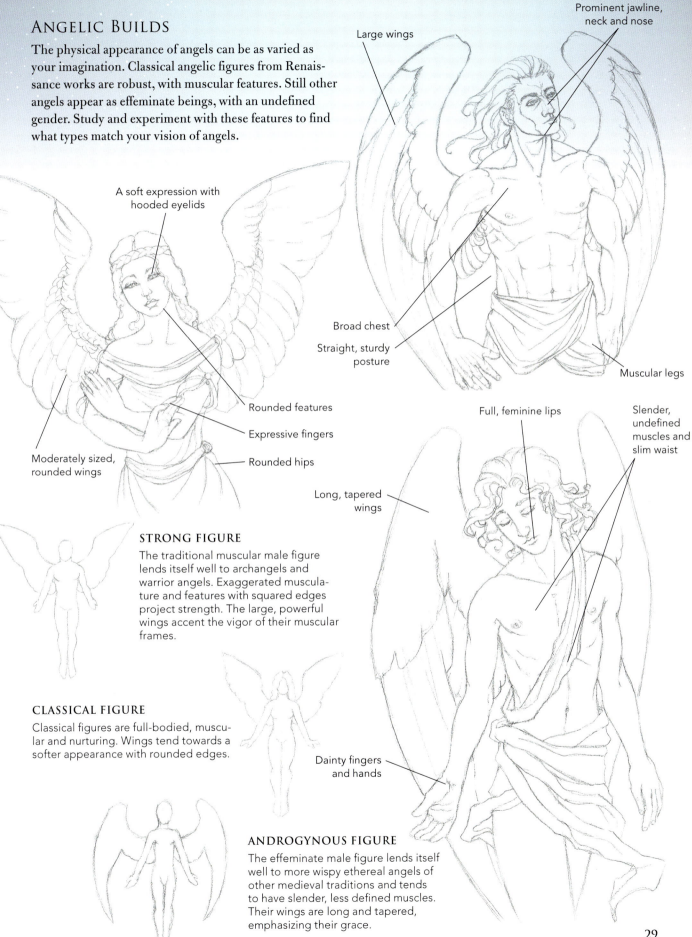

Large wings

Prominent jawline, neck and nose

A soft expression with hooded eyelids

Broad chest

Straight, sturdy posture

Muscular legs

Rounded features

Expressive fingers

Rounded hips

Moderately sized, rounded wings

Full, feminine lips

Slender, undefined muscles and slim waist

Long, tapered wings

STRONG FIGURE

The traditional muscular male figure lends itself well to archangels and warrior angels. Exaggerated musculature and features with squared edges project strength. The large, powerful wings accent the vigor of their muscular frames.

Dainty fingers and hands

CLASSICAL FIGURE

Classical figures are full-bodied, muscular and nurturing. Wings tend towards a softer appearance with rounded edges.

ANDROGYNOUS FIGURE

The effeminate male figure lends itself well to more wispy ethereal angels of other medieval traditions and tends to have slender, less defined muscles. Their wings are long and tapered, emphasizing their grace.

FACIAL PROPORTIONS

THE FACE IN PERSPECTIVE

Drawing facial features can be one of the most exciting and challenging parts of drawing angels. The face—particularly the eyes and mouth—tend to draw a viewer's attention and interest first. Taking the time to concentrate on facial features will help you create more engaging characters. The facial proportions described below prescribe a certain set of measurements that are especially pleasing to the human eye, but you can play with these proportions to create more unearthly characters or exaggerated expressions.

Notice how the facial features do not simply sit flat on the face when viewing the head at various angles. The proportional lines that the eyes, nose and lips lie on conform to the curved contours of the skull. Bear this in mind when drawing the face from alternate angles. Drawing the head without hair first also helps to keep your proportions in order, even if it looks quite odd to begin with!

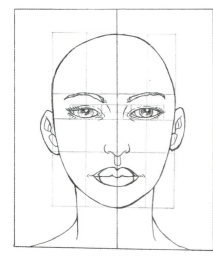

DIVINE PROPORTIONS

Proportions vary from face to face, but these classical measurements are considered the ideal. The head is three equal portions in length and two equal portions in width. The eyes lie along the line bisecting the face in half and are an eye-length apart. The nose lies on the line delineating the top of the bottom third of the face. The mouth lies on the line bisecting the bottom third of the face. The lines that divide the left and right sides of the face into quarters line up with the centers of the eyes and the corners of the lips.

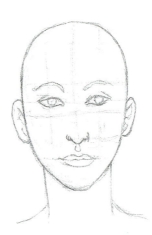

FRONT

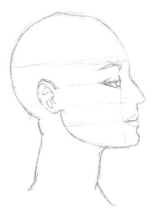

PROFILE

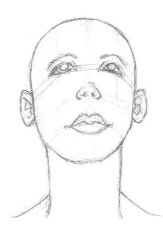

THREE-QUARTERS ANGLE

EXTREME PERSPECTIVE

FACIAL FEATURES

Taking the time to add personality and detail to the faces of your characters will pay off in the end. Even an interesting overall design can fail if your character is boring and expressionless.

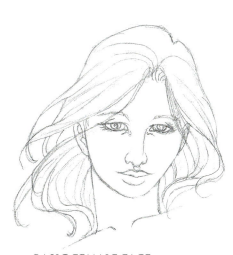

BASIC FEMALE FACE
Half-closed eyes and softly smiling lips suggest compassion and gentleness.

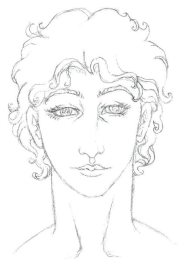

ANDROGYNOUS FACE
Thicken the eyebrows a bit to keep some of a masculine edge, but make the lips somewhat full and the jawline rounded and delicate to add that touch of grace.

CHILDLIKE FACE
Children have larger eyes and a larger head proportionally, which adds to their innocent appearance. The face and cheeks are rounded and full with a less prominent chin. The traditional soft curls can add an angelic accent to childlike features.

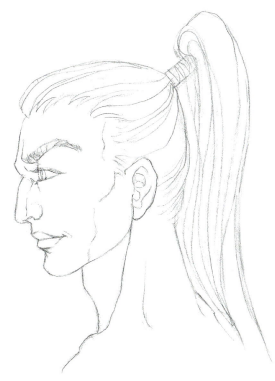

STRONG MALE FACE
A chiseled chin coupled with high, defined cheekbones and a face accentuated by thick eyebrows suggest a strong, handsome figure. A neck with thick, corded muscles emphasizes this effect.

SUGGESTED READING

- *Atlas of Human Anatomy for the Artist* by Stephen Rogers Peck
- *Bridgman's Complete Guide to Drawing From Life* by George B. Bridgman
- *Heads, Features and Faces* by George B. Bridgman

Hair

Floating, heavenly tresses and bejeweled braids are some of the many ways to show the grace and heavenly beauty of angels. When depicting hair, try to keep in mind a general flow that the majority of hair will follow. Drawing hair flying every which way can make your composition too chaotic. You don't want your angel to look as though she just stuck her finger in an electrical socket!

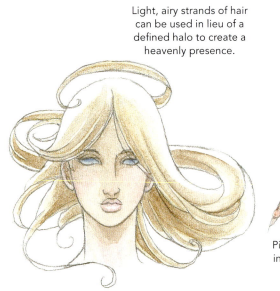

Light, airy strands of hair can be used in lieu of a defined halo to create a heavenly presence.

LONG WAVY LOCKS

Long and wavy locks are a traditional favorite for angels, allowing you the flexibility to accentuate graceful curves or halos around the head. For decorative purposes, hair need not obey all physics, as light airy curls can be indicative of the heavenly aura and power that angels exude.

Pile the braids in a twist for a regal look.

BRAIDED HAIR

Braids can add an exotically beautiful touch to an angel. Try combining braids with gems for an elegant, refined quality. Lump braids in piles for a striking look or use them sparingly for a classier feel.

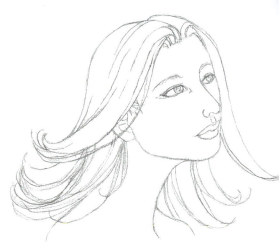

Hair tumbles in sheets rather than random strands.

HAIR PHYSICS

Hair isn't just an amorphous blob. It sits on the head in layers. When depicting realistic hair in motion, bear in mind that the hair sits on the head in three basic sheet-like layers: one attached to the top of the head; the second attached to the middle of the back of the head; and the third attached at the nape of the neck.

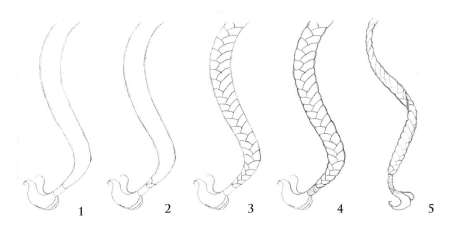

DRAWING A BRAID

1. Start with a tubelike shape that defines the path of the braid. A braid grows more narrow near the ends of the hair.
2. Starting at the bottom of the braid, draw a backwards Y to delineate the area where the strands overlap.
3. Continue drawing the interlocking Y-shapes until you've filled the braid.
4. Give the braid dimension by adding curves on the outer edges.
5. When a braid curves and twists, you will see less of the crisscross pattern and more of the edge of the side.

demonstration:
HEAD, FRONT VIEW

Now it's time to put what you learned about facial proportions and creating presence with facial features to good use. Adding personal touches like styled hair and interesting facial features can aid you in crafting interesting characters.

MATERIALS

*Mechanical pencils
(0.5mm and 0.7mm lead)*

Pen (0.1mm with black ink)

White plastic eraser

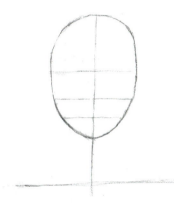

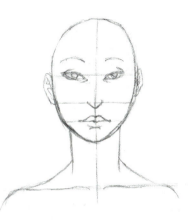

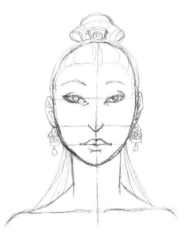

1 Draw the Basic Shapes
With a 0.7mm mechanical pencil, lightly draw the basic shape of the head, using an oval and lines for the shape of the neck and shoulders. Then, draw the basic guidelines.

2 Add the Facial Features
Following the guidelines, draw in the lips, nose, mouth and ears with a 0.7mm pencil. Make the angel's jaw slimmer, with more prominent cheeks and slanted eyes for an exotic look.

3 Refine the Hair and Other Details
Using the 0.5mm mechanical pencil, add the wisps of hair and finalize the details in her facial features. Jewelry gives her an elegant look.

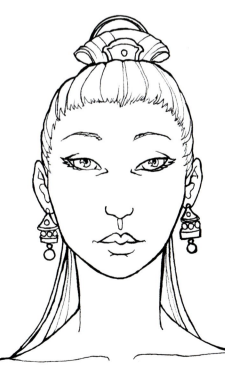

4 Ink the Drawing
Use a 0.1mm pen to ink the drawing, adding thicker lines where necessary to imply volume and shadows. After the ink dries, erase the pencil lines.

demonstration:
HEAD, THREE-QUARTERS VIEW

The three-quarters view of the head is interesting because it shows the shape and volume of the facial features' structure. If you are drawing the same character from multiple perspectives, try to keep the same measurements and proportions in mind to preserve consistency and make the character look the same.

MATERIALS

*Mechanical pencils
(0.5mm and 0.7mm lead)*

Pen (0.1mm)

White plastic eraser

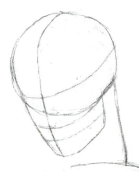

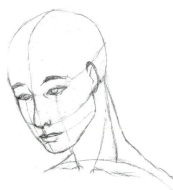

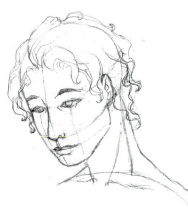

1 Draw the Basic Shapes
With a 0.7mm mechanical pencil, lightly draw the basic shape of the cranium using a circle and a squared-off triangle for the jaw. Lay down a softly arched vertical line to show the curve of the spine and neck. Then, draw a curved horizontal line as a guideline for the figure's shoulders. The jaw of this male angel is more square, while a female's jaw would be thinner and rounded. Then, draw the basic guidelines for the facial features.

2 Add the Facial Features
Following the guidelines, draw the lips, nose, mouth and ears with a 0.7mm pencil. Sweeping curved lines flowing from the hairline indicate how the hair will flow. Make the figure lithe and androgynous, adding thin, delicate lips and sinewy muscles. At this angle, the nose always lines up with the vertical center of the face, though the protrusion of the bridge of the nose hides the far nostril.

3 Refine the Hair and Other Details
Using a 0.5mm mechanical pencil, add more detail to the hair, muscles and facial features. Add curly hair to emphasize his gentleness.

4 Ink the Drawing
Ink the drawing with a 0.1mm pen. Erase the pencil sketch lines and your ink drawing is complete. Add a final spackling of freckles to add to his innocent appeal.

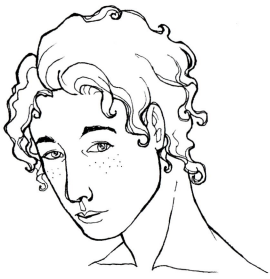

demonstration:
HEAD, PROFILE

The profile view of the head is a wonderful angle for illustrating the prominent features of the face at their highest dimension, particularly the nose. Again, if you are trying to draw the same character from a different angle, keep your previous images handy so you can compare proportions and keep the character consistent.

MATERIALS

*Mechanical pencils
(0.5mm and 0.7mm lead)*

Pen (0.1mm)

White plastic eraser

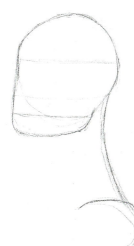

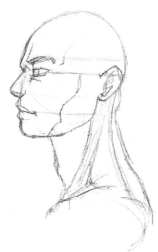

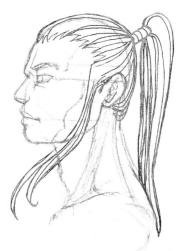

1 Draw the Basic Shapes
With a 0.7mm mechanical pencil, lightly draw the basic shape of the cranium using a circle and a squared-off triangle for the jaw. Lay down an arched vertical line to show the curve of the spine and neck. In this view, the curve of the spine is more prominent than it is in the three-quarters view. Then, draw the guidelines for the facial features.

2 Add the Facial Features
Following the guidelines, draw the facial features with a 0.7mm pencil. The length of the ear is equal to the distance from the line of the nose to the line of the eyes. This figure is a muscular male, so place more emphasis on his broad shoulders, prominent jawline and nose and defined brow.

3 Refine the Hair and Other Details
Using a 0.5mm mechanical pencil, add more detail to the hair, muscles and facial features. Defining thick, corded neck muscles adds to the masculine appeal of this figure.

4 Ink the Drawing
Ink the drawing with a 0.1mm pen and erase the pencil lines.

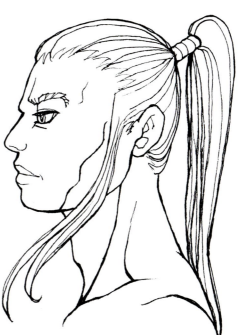

HANDS

One's excitement about depicting the human figure often turns to dread when it's time to draw the hands. Though this fear is certainly founded—rendering realistic hands is easily one of the most difficult things to learn—don't let yourself get discouraged! If you can master these complicated elements, you can add yet another level of expressive quality to your figures. Don't hide your figure's hands behind her body or another background element. Instead, be fearless in the face of complex forms. Look at your own hands and draw them over and over until you get tired of them. Practice, repeat and practice some more. You'll be drawing hands in no time!

OPEN HANDS

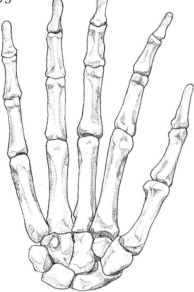

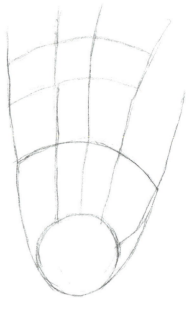

SKELETAL FORM

The basic form of the hand is highly influenced by the skeletal form beneath. The joints and ligaments under the surface add to the subtle complexities of the hand's structure.

SIMPLE BREAKDOWN

Break down the forms of the skeleton into a circle for the wrist and five lines radiating from the circle for the fingers. The joints and knuckles align along a sweeping curve. Keep this curve in mind when the hand is in different positions. The palm and the middle finger are of equal length.

ADDITIONAL OBSERVATIONS

The bone structure, which is most prominent in the knuckles and protruding joint of the thumb, gives the hand its convincing shape. The palm is not a flat area. It contains lines and wrinkles that radiate from the intersection of the thumb and fingers.

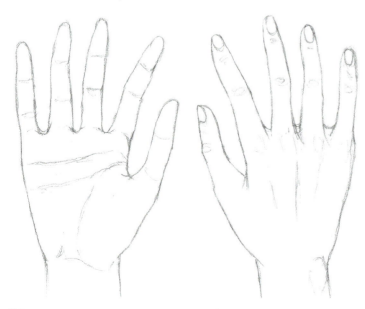

SUGGESTED READING

- *Drawing Dynamic Hands* by Burne Hogarth

CLOSED HANDS

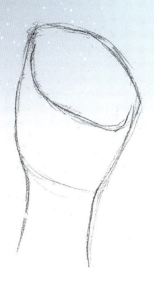

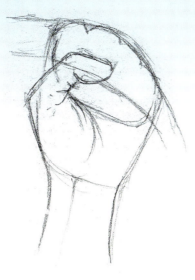

BEGIN WITH THE BASICS

When the hand is closed, the joints protrude even more than they do on the open hand. Generally, the thumb curls around the second main joint of the index and middle fingers. Think of the basic shape of the fist as an oven mitt containing the fingers.

INDICATE THE JOINTS, KNUCKLES AND PALM

The square part of the palm is accented by the fingers, with the middle finger being the tallest joint. The lines of the palm, radiating from the thumb, become more defined in a fist. Use a guideline across the knuckles to line up and draw the joints.

FINISH THE FIST

Detail the planes of the fingers and joints, using the guidelines to keep the knuckles in order. When bent, the knuckles of the hand are squared off.

DRAWING EXPRESSIVE HANDS

Don't underestimate the expressive quality of hands. Clenched fists can suggest anger or intense emotion, while dainty spread fingers and elegantly curved wrists can connote graceful movements. In many classical figures, the relaxed pose of the hand with slightly bent figures suggested a holy presence and a tranquil personality. Don't draw just a flat, open hand. Play with the shape and structure and try something more expressive!

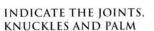

Spread fingers and delicate wrists add to a figure's graceful presence.

FEET

Like hands, feet can be one of those difficult conundrums of figure drawing that cause us to shy away or cover them with heavy, formless boots. But just as hands can add an expressive quality to a figure, feet, too, can convey emotion. How can feet be emotional? Just bear with me and you'll see!

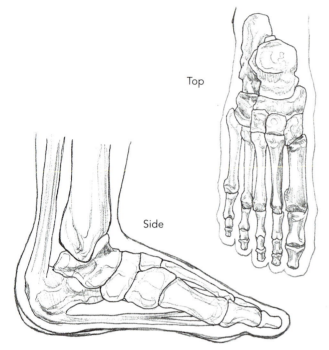

Top

Side

Ankle

Instep

Ball of foot

SKELETAL FORM

By learning the basic bone structure of the feet (or any part of the anatomy), we begin to understand why the surface of the body has the subtle curves, dips, and protrusions that make anatomy believable when translating it into our figures. Try practicing skeletal structure by sketching the skeleton of your figures on top of photos to get a better understanding of the way the body moves and the subtle combination of skeletal structure and muscle that blends to form the figure.

SIMPLE BREAKDOWN

The foot is made up of many underlying shapes which lend to a form with dips and rises in key places, particularly on the ankle, instep and ball of the foot.

SUGGESTED READING

- *Drawing Hands and Feet: Form, Proportions, Gestures and Action* by Giovanni Civardi

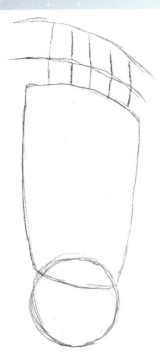

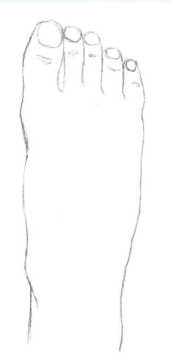

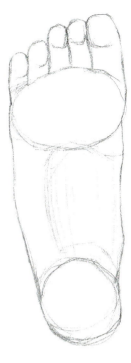

BEGIN WITH THE BASICS

The basic shapes of the foot are similar to the hand, with a few exceptions. Begin with a circle for the ankle joint, then add an elongated version of the rounded square (the hand's palm). The knuckles of the toes align along a curve.

THE TOP OF THE FOOT

Draw the individual toes, remembering to add toenails and include dimples along the joints. Use the circle of the ankle joint from the previous step as a guideline for drawing the ankle itself. The subtle joints of the ankle make the area of the foot particularly convincing. Study your own foot as reference for the subtle planes and tendons present.

THE BOTTOM OF THE FOOT

Like the palm of the hand, the bottom of the foot contains lines and wrinkles that define the subtle muscle wrapping around the intricate tendons of the foot to create pad like areas. As a general guideline, toes are like little rectangles with round spheres on the end representing the pads of the toes.

DRAWING EXPRESSIVE FEET

Like hands, feet can play a large part in emphasizing the expressive movement of a figure. Curled toes and bent ankles suggest a dancer's movement and grace. Pointing the feet in this way also emphasizes the rounded shape of the calves, giving the legs a pleasing accentuated curve. High-heeled shoes are considered fashionable and beautiful because they accentuate these delightful curves.

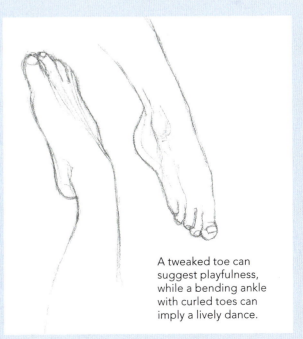

A tweaked toe can suggest playfulness, while a bending ankle with curled toes can imply a lively dance.

WINGS

Wings are one of the most remarkable trademarks of the angelic figure. Though they are not a requirement for every angel, plumage emphasizes the angel's otherworldly nature and provides an opportunity to be creative and have fun with the design. The wings of swans serve as an excellent reference for the basic angel wing. Try observing these gorgeous creatures at your local park or zoo and keep a sketch pad or camera handy for reference images.

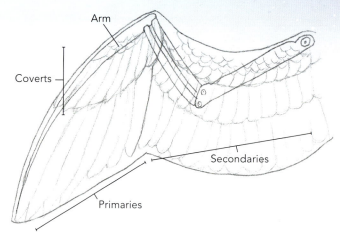

MAJOR SHAPES OF THE WING

Wings are comprised of three major layers of feathers: the small, scale like feathers near the arm structure; the medium-length feathers that form the coverts; and the long feathers of the primaries. To remember the correct shape of longer primaries at the tips of the wings, think of them as the spread fingers of the wing.

SKELETAL FORM

The skeletal structure of the wing is delicate. The arm-like construction holds the bulk of the wing's weight, while the feathers are attached in flat planes layered over one another.

OUTSTRETCHED WINGS

Wings should not appear as a flat piece of paper attached to your angel's back. They have joints and an overall curved structure comprised of smaller feathers. When viewing your figure from different perspectives, keep in mind the way the wings project from the back and curve around the body.

THE BENT WING

The joints of the wing move similarly to those of the human arm. The "elbow" of a bird's wing is less prominent, while the "shoulder" and "wrist" are more emphasized. Bear this in mind when drawing bent wings. Nothing looks more awkward than a wing that curves in a circular fashion with no sign of joints!

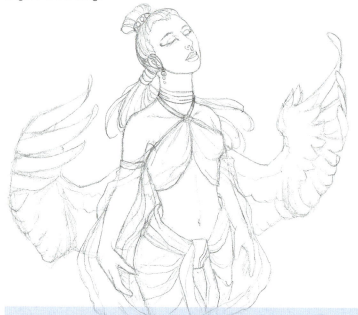

EXTREME WING PERSPECTIVE

Drawing wings in extreme perspective can be very challenging. Visit birds at your local park or zoo to help build your knowledge of what the wing looks like at odd angles. Playing with perspective can add a whole new level of interest to your figures.

DRAWING FEATHERS

Wing feathers are composed of a shaft and soft filaments that spread outward from this stem. Tiny barbs within these strands make the filaments stick together, keeping the feather flat. Drawing every tiny detail isn't necessary for creating convincing feathers. In fact, too many details can make your feathers look too busy. However, if a feather is closer to the foreground, be sure to add details that make it appear closer to the viewer. Hinting at the contours of the filaments with light hatching or breaks in the straight edge of the feather will add a level of realism to the wings.

FEATHER VARIATIONS

Different parts of the wing are composed of a variety of feather shapes. Feathers on the primaries tend to be long and tapered, while feathers on the coverts are generally more rounded off. The feathers near the wing arms are softer and downier with fewer hard edges. Avoid making your feathers too ordered or they may end up looking like fish scales or roof tiles instead.

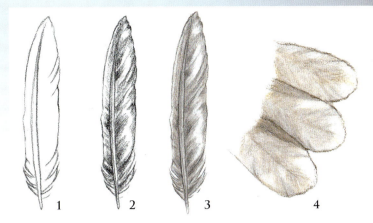

1 2 3 4

COLORING A FEATHER WITH COLORED PENCIL

1 Start by tracing your sketch of a feather with Black.

2 Add the major shadows with layers of Warm Grey 70%, placing strokes of Black in the deepest shadows. Use light strokes and layer them line by line.

3 Smooth and blend by coloring over the previous layers with White. For more pronounced shadows, go back and add more strokes of Warm Grey 70%.

4 *Note:* If the feathers are illuminated from behind, their semi-translucent quality will allow you to see the shadows of the hidden portion of the feathers where they overlap.

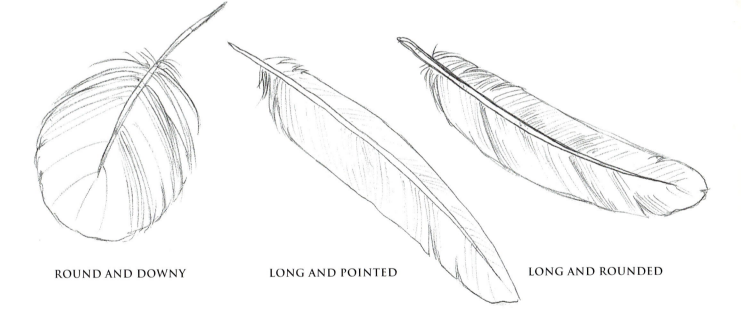

ROUND AND DOWNY LONG AND POINTED LONG AND ROUNDED

COLORING WINGS

When coloring wings, keep in mind that the backside of the wing is generally not as brightly colored as the underside. Bear this in mind if you want more realistic bird wings. However, considering the fantastical nature of angels, anything is possible!

ORNAMENTAL WINGS

Unlike birds, angels can appreciate the addition of adorn-
ments to their wings. Take a cue from angel artists like

Edward Burne-Jones and Rogier van der Weyden and
play around with wing colors, shapes and markings.

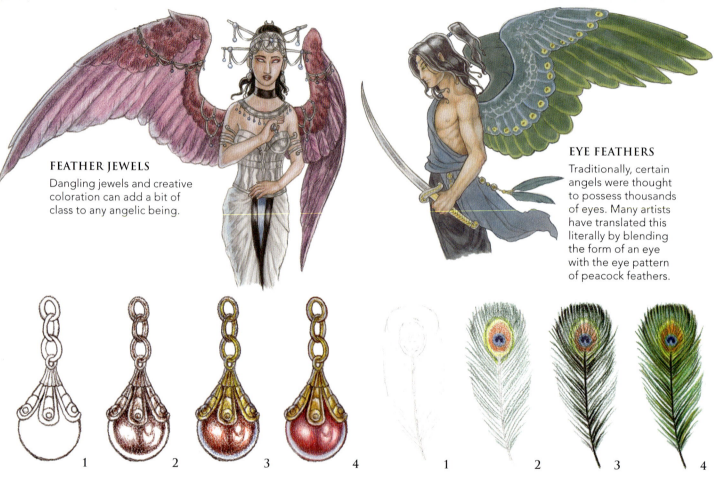

FEATHER JEWELS
Dangling jewels and creative
coloration can add a bit of
class to any angelic being.

EYE FEATHERS
Traditionally, certain
angels were thought
to possess thousands
of eyes. Many artists
have translated this
literally by blending
the form of an eye
with the eye pattern
of peacock feathers.

JEWELS IN COLORED PENCIL

1 Start with a sketch of the jewel. Pearlescent rounds are a
 simple, elegant shape. Outline the jewels with the darkest
 colors in your palette. In this case, I've used Dark Umber
 for the jewel rounds and golden chains.

2 Add shadows to the jewel with Tuscan Red and touches of
 Dark Umber for the deepest shadow. Add shadows to the
 gold chain with Sienna Brown, using Dark Umber for the
 darkest shadows.

3 Add the jewel midtones with Crimson Red and to the gold
 chain with Canary Yellow. Layer in Light Cerulean Blue at
 the edge of the shadow for reflected light.

4 Burnish the highlights of the chain with White and Sand.
 Smooth the jewel, using Pink Rose and White to blend
 the highlights and Cloud Blue to blend in the reflected
 blue light. Pick out any lost detail with the midtone and
 shadow colors.

PEACOCK EYE FEATHERS IN COLORED PENCIL

1 Block in the shapes with circles for the eye pattern.

2 Outline the texture in Peacock Green, using wispy lines.
 Add the rings of color in the eye, using Indigo Blue for
 the innermost "pupil," True Blue for the middle ring and
 Pumpkin Orange for the outer ring. Trim the outer ring
 of orange with successive rims of Dark Green and Canary
 Yellow.

3 Add shadows by interspersing wisps of Dark Green.
 Accent the deepest shadows with Dark Umber on top of
 the Dark Green wisps.

4 Build up the feathers using True Green and Canary Yellow
 for the main green portion of the feather and Cloud Blue
 for the inner eye rings. Smooth the blending overall with
 strokes of Sand. Finish off the feather by redefining the
 details of the wisps with Dark Green and Dark Umber.

Non-Traditional Wings

Considering the profoundly mystical nature of angelic beings, why confine yourself to traditionally shaped wings? Colorful markings, wings made of flowing lines, or even multiple sets of wings can add an exotic and majestic feel to an angel. Creatively designed wings can also add a level of storytelling to a character's design. The only limits are the limits of your imagination.

MAN-MADE WINGS
Mechanical wings imply an angel with an industrial slant, maybe one who isn't an angel at all! Or perhaps this faux wing is a replacement for a wing lost in battle?

MOTH WINGS
This angel's wings bear the markings of a silk moth's wings, suggesting a mystical link between the angel and the night's winged denizens.

MULTIPLE WINGS
Traditionally, angels of the upper echelons of heaven have numerous sets of majestic wings.

HYBRID WINGS
Blending bat and birdlike wings can add an exotic edge and implies a hybrid mix of angel and demon. Would such a being be good or evil?

demonstration:
DRAWING GILDED WINGS

Though not a requirement for depicting angels, wings add to the spectacle of beauty these heavenly creatures possess. Angelic wings are unrestricted by color and convention, with each angel's wings saying something about her personality.

This angel's figure and the form she is resting upon have already been painted using watercolors. The primary objective of this demonstration is to practice drawing wings.

MATERIALS

COLORED PENCILS

Cream, Dark Brown, Dark Umber, French Grey 70%, Light Umber, Sienna Brown, White, Yellow Ochre

OTHER SUPPLIES

Pencil sharpener

White plastic eraser

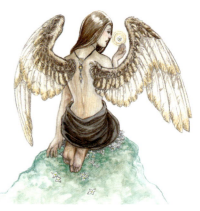

1 Draw and Outline the Wings
Draw the wings projecting from the shoulder blades, keeping the main surface of the wings mostly parallel to the back. Because the left shoulder of the figure is slightly farther away from the viewer, foreshorten the left wing to follow the direction of the bend in the shoulder blade. Then, outline the sketch of the wings with Dark Umber.

2 Apply the First Layers of Color
Lay in a very light layer of Yellow Ochre over the entire wingspan. Continue building up the layers with Yellow Ochre over the wing tips to create more striking markings. Add a layer of Light Umber to the top of the wing arms so that the wings fade from dark brown to a light dusting of gold. Keep your pencils sharp so that it's easier to apply even layers of color for smooth blending.

3 Build Shadows and Texture
Use layered hatching strokes of Dark Brown to accentuate the deepest shadows and textures of the feathers. For the darker shadows in the brown feathers, layer more heavily with Dark Brown.

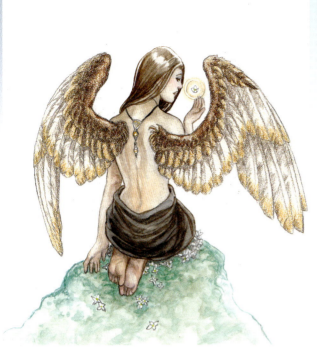

4 Further Develop the Colors
Continue building up the layers with French Grey 70% in the shadow of the white parts of the feathers. Layer with Sienna Brown to add a gold tinge to the wing arms.

5 Burnish and Blend the Colors
Smooth the color applications by burnishing the white parts of the feathers with White and the gold and brown bits with Cream. If the blending doesn't work smoothly, continue building up with consecutive light layers of Yellow Ochre, Light Umber and French Grey 70%. If the colors become too dark or murky, or your paper becomes too saturated with pigment, you can strip away some of the layers with a white plastic eraser. This will always leave a slight residue of color behind.

6 Add Finishing Touches
Finally, define the major shapes and textures of the feathers with Dark Brown. Feathers have a soft texture made of many strands. Emulate this by applying your strokes in loose and layered hatching.

CARING FOR COLORED PENCIL ART

Over time, colored pencil works tend to gain a light halo of dust, which can make the art look faded and smudged. Worse still, the color can rub off on other art. You can prevent this by applying a layer of fixative. If the idea of permanence scares you, workable fixatives that allow you to continue adding layers of color are also available.

SKIN TONES

Painting skin can be one of the most intimidating aspects of rendering convincing figures. However, it is easy with a little observation and practice. The trick to skin tones is remembering that it isn't merely a solid peach or brown tone. Make more convincing skin tones by mixing colors such as yellow and red for a vibrant color.

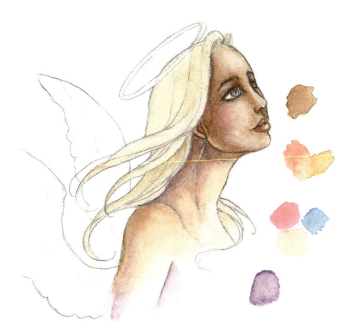

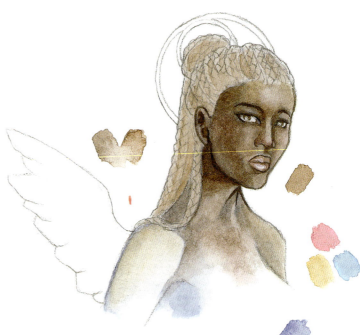

LIGHT SKIN

A mixture of Cadmium Red and Yellow Ochre creates a soft blush tone that is the base for lighter skin.

1 Apply an underlayer of shadows with Dioxazine Violet, or alternatively with Ultramarine Blue.

2 Emphasize the subtle tones in the skin with Cerulean Blue around the eyes, Rose Madder in the cheeks, nose and lips, and a light layer of Naples Yellow on the forehead and shoulders.

3 Mix a touch of Cadmium Red with Yellow Ochre, and apply a light glaze of this mixture. Be careful not to use too much Cadmium Red or you'll end up with a blushing angel!

4 Deepen and smooth the shadows with washes of Burnt Umber. Smooth highlights with Chinese White where needed.

DARK SKIN

For darker skin, try a mixture of Van Dyke Brown and Burnt Sienna to suggest a warm blush. Alternatively, Payne's Gray and Burnt Umber can work as a base tone for skin with a cool hue.

1 Apply an underlayer of Ultramarine Blue for the skin's shadows.

2 Emphasize the subtle tones in the skin with Cerulean Blue around the eyes, Rose Madder in the cheeks, nose and lips, and a light layer of Yellow Ochre on the forehead and shoulders.

3 Add successive washes of Van Dyke Brown mixed with Burnt Sienna until you reach the desired darkness, allowing each layer to dry before applying the next.

4 Deepen the shadows with Burnt Sienna and smooth highlights with Chinese White where needed.

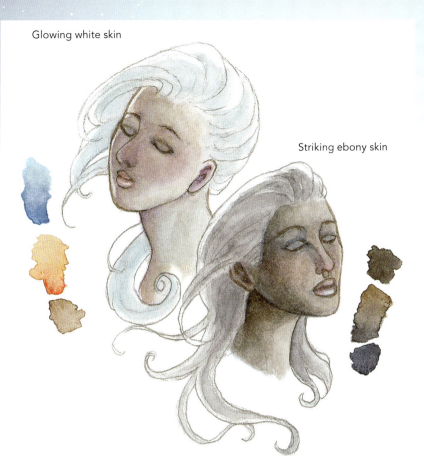

Glowing white skin

Striking ebony skin

DELICATELY FAIR SKIN

For glowing fair skin, try an underlayer of blues or pinks and a base tone mixed from the usual blend of Yellow Ochre and Cadmium Red, adding a touch of Chinese White to the mix. Keep the glazes thin. Remember that white areas of color tend to reflect the colored objects around them. Incorporate these colors into your palette. Apply faint washes of Cerulean Blue, Cadmium Red and Naples Yellow to create subtle tones in pearlescent skin. Finish with a very pale, thin wash of Chinese White, mixed with a small amount of Cerulean Blue to smooth out the highlights and add another level of pearlescence to fair skin.

EBONY BLACK SKIN

For striking ebony tones, try an underlayer of Indigo or Dioxazine Violet for the shadows and a base tone mixed from Payne's Gray with touches of Burnt Umber. Lamp Black or Ivory Black can be used for deepening the shadows. For ebony skin with an unearthly vibe, try using more violets, greens or blues to emphasize the subtle tones in the skin.

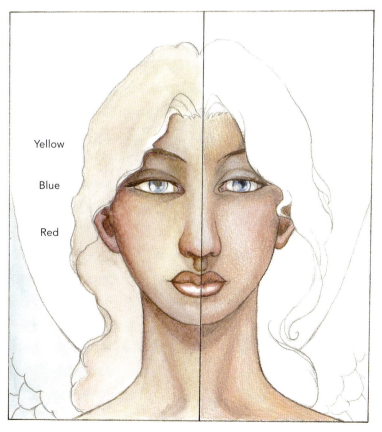

Yellow

Blue

Red

SUBTLE TONES IN SKIN

If you look closely, there is a redder blush around areas where bone comes close to the surface of the skin, such as the elbows, knuckles and fingertips. In thinner, more delicate areas, such as around the eyes, the tones are more blue. Skin that has been exposed to the sun has a more yellow tint. Shadow tones in skin tend to be cooler. Experiment with your palette and work with light glazes of color to emulate the translucent luminosity of skin.

FABRIC AND CLOTHING

From draped luxurious fabric to leather armor, clothing can be an important factor in setting the mood for your angelic figures.

The first thing to consider is the body beneath the cloth. Instead of thinking of a figure and clothing as a single entity, draw the figure and then layer the clothing on top.

SILK AND SATIN
These materials are extremely flowing and prone to wrinkling in loose, form-fitting curls around the figure. They also have a slight sheen.

BEGIN WITH THE BASICS
Starting with the basic form allows you to envision how parts of the figure will interact with the clothing. To make cloth draped over a figure convincing, we should see the subtle hint of the figure's contours underneath. Some fabrics will cling to the figure more closely, such as spandex or tight leather. Other materials, such as brocade and linen, are stiffer and therefore less form fitting.

BROCADE AND LINEN
Heavier materials are stiffer and do not pick up as many contours as silk and satin.

TYPES OF MATERIAL
When considering clothing for your angels, think about the type of cloth they will be adorned with. Fabric behaves differently depending on what type it is.

TAFFETA AND CHIFFON
These sheer materials flow smoothly while revealing a slight hint of color and shape of the layers beneath. Some sheer cloth is crisper, leading to folding stiff layers similar to those of heavier materials.

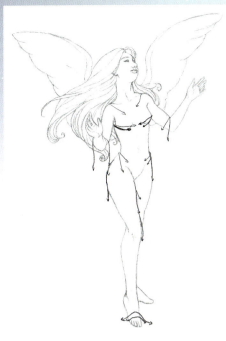

ESTABLISH THE FLOW OF TENSION AND GRAVITY

Cloth tends to fall downwards or gather at seams, pleats and buttons. It wrinkles as it nears seams and stretches slightly against gravity before being pulled downward into its natural flow.

This angel's raised arms will cause the cloth to gather at the pinch of her forearms and stretch straight across the bosoms to the dress seams, converging at her underarms. It will flow over her bent forward knee and fall back under the knee, causing wrinkles in flowing cloth.

SUGGEST VOLUME

After establishing the flow of the dress, add volume to the cloth by thickening the material and suggesting overlaps. The wrinkles settle downward against one another as they slide away from her waist and the cloth settles on top of itself at her elbows. The cloth pools at her feet and spreads across the ground, where the excess folds over itself in small ripples.

ADD HEAVY CLOTHING

Heavier clothing obscures much more of the figure's contours. Stiffer material wrinkles less across the smooth and flat surfaces of the form, but it can gather in thicker ripples when it is contained by knots or decorative cuffs.

STUDYING CLOTHING AND INTERNET RESOURCES

Study different fashions, such as Victorian and Napoleonic dresses, to learn how flowing gowns fall across a figure's points of tension. The Baroque artists were particularly adept at painting and drawing realistic cloth or adapting it into stylized shapes for decorative purposes. Knowledge is your best defense against lumpy, lifeless, badly drawn clothing. Check out the following Internet costume resources:

- Demode (www.demodecouture.com): This website is dedicated to vintage fashions and information.

- Michaela de Bruce (www.costumes.glittersweet.com): This informative site has plenty of pictures of German historical costumes, Spanish costumes, and more.

- The Fashionable Past (www.koshka-the-cat.com): This in-depth site on fashion in the seventeenth century, Regency and many other eras includes inspiring costumes.

- The Costumer's Guide (www.costumersguide.com): This is a guide to movie costumes with many galleries of images and notes.

HALOS

Angels are commonly portrayed wearing halos, symbols that signify their divinity. Although halos are most often depicted as golden orbs or rings around the head of an angel, you need not confine yourself to such traditional depictions.

The halo can say a great deal about the angel it adorns, acting as a visual representation of a particular personality trait or conveying a specific type of energy or mood. For example, a flaming halo could very easily connect your angel to the element of fire, suggesting fury or wrath, while a halo constructed of ice crystals could imply your angel guards a frozen tundra. Be creative and think beyond the golden loop!

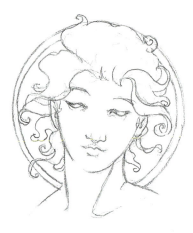

CLASSICAL HALO

Usually a simple gold ring or circle around the head, the classical halo has been represented in art throughout the ages.

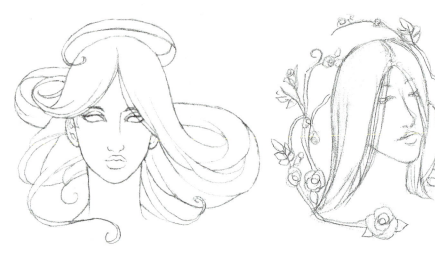

FLOWING HALO

Implied by wild and free hair, the flowing halo suggests inner power and beauty.

FLOWER HALO

A halo of flowers suggests peacefulness and a nurturing power that encourages things to grow.

IMPLIED HALOS

A more modern approach to depicting the halo is to imply its presence with light or lines. Inspiration for non-traditional halos can be drawn from many sources, including Buddhist mandalas or your own imagination!

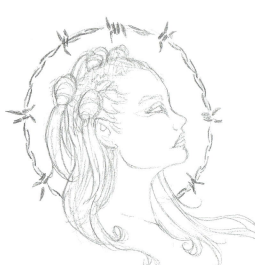

HALO OF STARS

A halo made of stars can be a decorative approach to suggest a heavenly connection to the celestial objects in the sky.

MILITARISTIC HALO

For a militaristic appeal, try a halo made from barbed wire.

demonstration:
CREATING AN IMPLIED HALO

MATERIALS

WATERCOLOR PIGMENTS

Burnt Sienna, Cadmium Yellow, Cerulean Blue, Dioxazine Violet

OTHER SUPPLIES

nos. 00, 2 and 6 rounds

Table salt

"A brilliant blade flashes in the deepest dark. All who fear the light know her, for she is the Terrible Dawn, the slaughterer of demons and the blinding brilliance of Heaven."

In this demonstration, you will focus specifically on laying in the implied halo; you will have a chance to finish this painting in the Painting a Tattooed Figure demonstration.

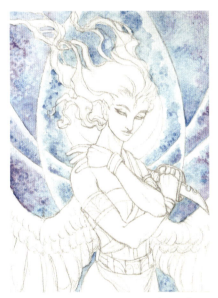

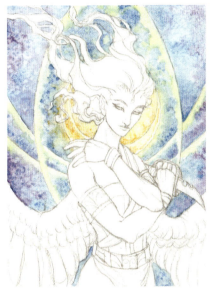

1 Apply the Background Wash
Using a no. 6 round, lay in a wet wash of Cerulean Blue with touches of Dioxazine Violet for color variation. While the wash is still wet, sprinkle the area with salt to create starburst blooms. Add more purple near the outer rim of the image so the blue radiates from the center and darkens, drawing attention to the angel. Be sure to leave the area along the halo lines white in order to create the effect of radiating light.

2 Lay In the Halo Basecoat
Using a no. 2 round and Cadmium Yellow, lay in golden accents of light over the radiating lines and the central part of the halo. Overlap the Cadmium Yellow with the blue just enough to blend the edges, but not so far that it muddles the colors. Add touches of yellow where there are white blotches around the head to imply a shimmering of light around her hair.

3 Define the Halo and Add Details
Tie it all together by outlining the central halo with Burnt Sienna using a no. 00 round. Add streaks of darker brown within the golden halo to suggest the directional flow of the light from her head.

Add visual interest to the background by accenting the random shapes created by the salt blooms using a no. 00 round and Burnt Sienna. If the brown becomes too overpowering, blend by layering with Cerulean Blue.

MARKINGS AND TATTOOS

Like halos, markings and tattoos are an effective way to establish characterization in your figures. The mere act of being tattooed suggests a resilience or toughness while adding visual edge to the character. These markings can also identify one's membership in a tribe or clan, or express an allegiance. The story possibilities are endless.

CELTIC KNOTS
This braided pattern works well for suggesting a warrior spirit or an angel that is both daring and brave.

TRIBAL WINGS
These markings can add both elegance and edge. For a more modern appeal, try using tattooed tribal wings in place of feathered wings.

FLORAL MARKINGS
Floral motif tattoos can add a feminine touch to your angel.

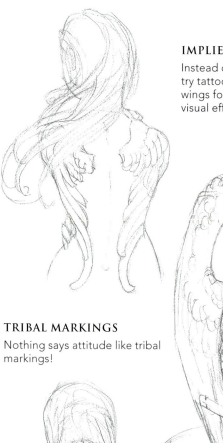

IMPLIED WINGS
Instead of actual wings, try tattooed feathered wings for an interesting visual effect.

TRIBAL MARKINGS
Nothing says attitude like tribal markings!

SIGILS
Sigils are magical signs or images and can suggest an attunement to magical energies or a higher hierarchy of angel. Creating your own sigils to adorn your characters can lend to a rich angelic vocabulary.

SUGGESTED READING
For gathering ideas about tattoos and how to draw Celtic knots, try these books:
- *The Grammar of Ornament* by Owen Jones
- *Draw Your Own Celtic Designs* by David James

demonstration:
PAINTING A TATTOOED FIGURE

The most important thing to remember about painting convincing tattoos is that they are semi-opaque in nature, meaning some of the skin color remains visible beneath the ink. They should also conform to the contours of the body and should never be flat unless they are on a flat surface or lined up head-on with the viewer's eye. Keep in mind that tattoos will also stretch with the skin during movement.

MATERIALS

WATERCOLOR PIGMENTS

Cerulean Blue

OTHER SUPPLIES

Pencil

no. 00 round

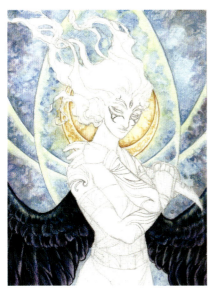

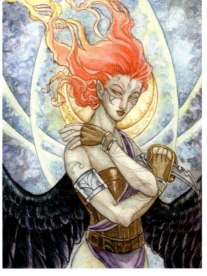

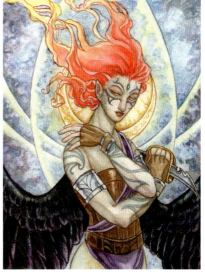

1 Sketch the Tattoos and Paint the Wings

Lightly sketch tattoos on the arms and around the eyes with a pencil. It is important to draw the tattoos before you begin painting so that the pencil lines won't be too strong in the finished design.

I chose darker wings rendered in colored pencil for this figure to accentuate her fearsome presence and contrast with her fiery hair. (See the Drawing Gilded Wings demonstration for more information on coloring wings.)

2 Render the Skin

Paint the skin as you would normally (using what you learned from the skin-tones lesson). Don't concern yourself with the tattoos or how the pencil lines are lightened after you paint on top of them.

I chose pale skin for this figure to contrast with her dark wings and to allow her tattoos to be very visible. The blue glow on her skin and wings ties in the cool hues of the tattoos and balances the image.

3 Color In the Tattoos

Paint the tattoos last using a no. 00 round and Cerulean Blue. Painting the tattoos on top of skin tones allows the skin beneath them to show through, creating a more realistic looking tattoo. Tattoos are hardly ever pure and solid in color and are almost always tinted by the tone of the skin beneath them. Layer more glazes of Cerulean Blue if you want the tattoos to appear more striking and intense. (Don't layer too much, however, or the tattoos will begin to look fake and more like war paint.)

WHITE TATTOOS

To color white tattoos, try using white gouache or white colored pencil on top of the fully colored skin. Both colored pencil and gouache are translucent enough to show some of the skin beneath so that the tattoos are convincing.

Weaponry

Throughout art history, angels have traditionally wielded weapons based on the world's most renowned ancient warriors of the time. While the powerful presence that traditional weapons lend to a design can add a majestic feel to your characters, you need not restrict yourself to dated symbolism. Play with your weapon designs and see how they suit your particular taste in fantasy angels. From mythic blades to bows and arrows, weaponry is limited only by your imagination.

Swords

Katana and rapier-inspired swords, with their slender shape and decorative handles, suggest a sleek and formal style of fighting suited for agile and graceful warriors. The heavier construction of claymores and gladius style swords suggest the raw power of the warrior wielding them and a certain amount of forcefulness.

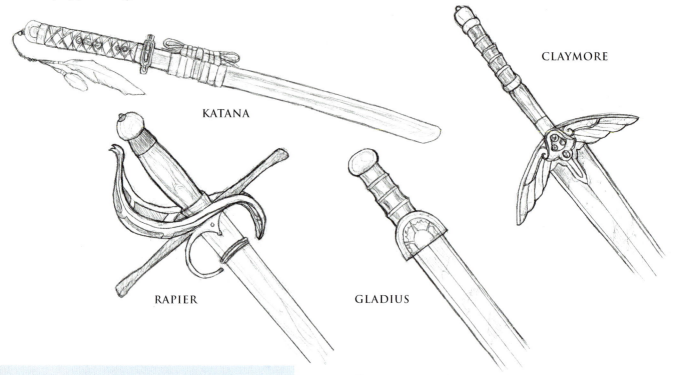

KATANA

CLAYMORE

RAPIER

GLADIUS

Drawing Convincing Weapons

As limitless as weapons are in shape and design, they too have texture and parts. The trick to drawing convincing weapons is to keep in mind the various elements that lead to a weapon's overall construction. How will your angel hold the weapon? Are there handles? Is there a guard to protect the fingers? Are the handles wrapped with leather for a more comfortable grip? Study real weapons and their structure before making your own.

Bow and Arrow

The favored weapon of hunters and long distance fighters, the bow takes keen vision, trained accuracy and concentration to wield effectively— all traits which define a dedicated warrior strong in mind as well as body.

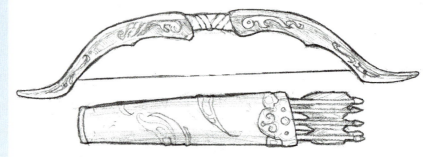

BOW AND ARROW

Armor

Like weapons, different types of armor consist of various textures and pieces that make up its total composition. From leather and chain mail to scale mail and plate mail, the combinations of textures offer an endless variety for attiring your angel.

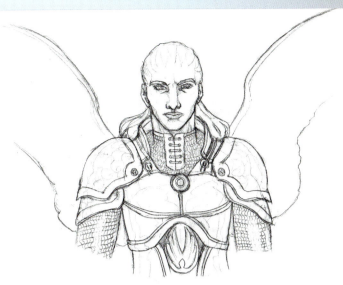

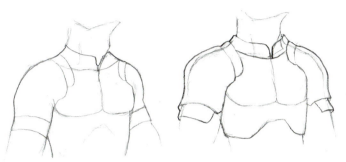

ARMOR DO'S AND DON'TS

Remember: Armor should not look like a T-shirt drawn over your character's body. It has layered bits and pieces and should project from the body as if it were layered on top.

Also keep in mind whether a character would be able to lift his or her arms or function in a suit of armor. If you make the breast plate all one piece, how could the character lift his arms? Likewise, does the armor protect vital parts of the body, like the heart? One could make the argument that angels are immortal and don't need functional protective gear, but that takes away the fun of designing realistic armor!

ARMORED ANGEL

Not only does armor protect your angel, but armor can say a lot about what the angel represents. A chest plate might bear the angel's insignia, while engraved feather like designs might add a touch of grace and ethereal intrigue to a heavily armored angel. Be creative!

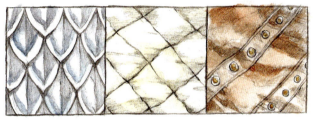

scale mail padded armor leather

POPULAR ARMOR TEXTURES

In addition to chain mail, consider dressing your angel with scale mail, padded armor or leather.

Drawing Chain Mail

SKETCH THE BASIC FORM

Chain mail shirts are generally worn under leather vests or tunics with an undershirt beneath it to prevent chafing. Remember: Because chain mail is made of metal rings, it will drape from the body like very heavy material.

SUGGEST THE LINKS

Draw sections within the armor to represent the layers of intersecting links, following the contours of the body. Then, add the chain mail rings by drawing C's in each row. Change the direction of your marks with each successive row to indicate the intersecting rings.

ADD HIGHLIGHTS

Once all of the texture is drawn in, use a kneaded eraser or a regular eraser to lightly lift out highlights on the armor, enhancing the reflective feel of the metal.

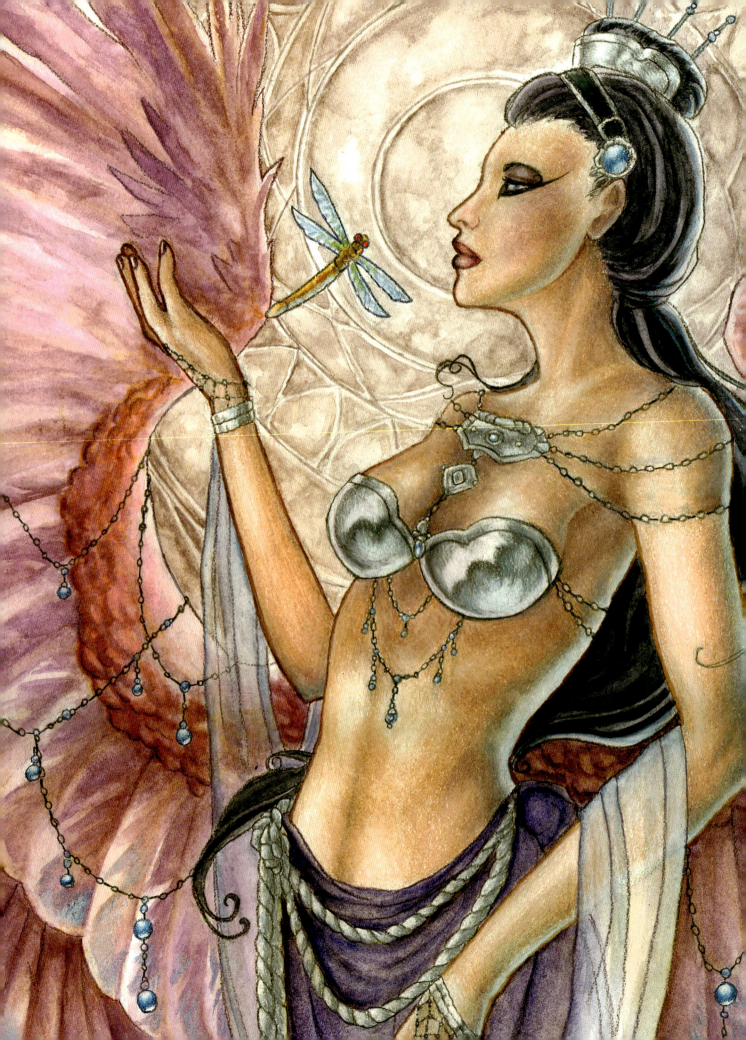

chapter three
SETTING
THE SCENE

SO YOU'VE THOUGHT ABOUT YOUR ANGELIC character. You have a basic idea of how you want it to look. Now it's time to ask yourself, "What should my character be doing?" (Perhaps you may have thought of this even before you designed your character!)

The setting you place your figure in can do so much to add atmosphere, presence and interest to both your figures and overall paintings. Setting can also imply narrative elements of your angel's story and can be used to direct a viewer's eye to certain parts of your figure. Settings should inform your character just as much as your characters inform the settings. If possible, it's best to think about both at the same time when crafting your image in its conceptual stages.

The following chapter will guide you through some basics of creating backgrounds for your angels and offer suggestions on where to draw inspiration.

CREATING THE PERFECT BACKDROP

As you already know, collecting photographic references can help spark inspiration or add a level of realism to your work that might not be achievable through imagination alone. Photographs can be particularly helpful when trying to determine the background setting, mood or thematic tone of your painting. Architectural reference photos are a great place to look for such ideas, as angels are commonly woven into the scenes and settings used in architectural elements like stained glass, stone carvings and frescos.

In particular, the decorative elements employed in Gothic cathedrals—structures created in medieval Europe—are an excellent resource when searching for the perfect background or theme for your paintings. With angels flitting between the columns in frescos and blessing the interior with light streaming from magnificent stained glass fixtures, you're bound to find the perfect inspiration for your angelic art.

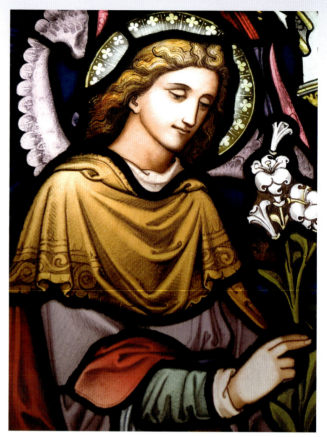

LOOK TO STAINED GLASS
The streaming light and vibrant jewel tones used in this scene make the angel glow with contentment, while her pose reflects a sense of serenity.

USING INTERNET REFERENCES

When using an image from the Internet, make sure that you are using it properly, even when referencing a pose from a stock image or photograph. This is important if you plan on sharing your artwork or incorporating the image online or anywhere else. Remember: It is always best to check the terms of use on any image and to ask before using it.

Here are some great online image resources for poses and architecture:

Dreamstime
(www.dreamstime.com)
CharacterDesigns.com
(www.characterdesigns.com)
Pose Maniacs
(www.posemaniacs.com)

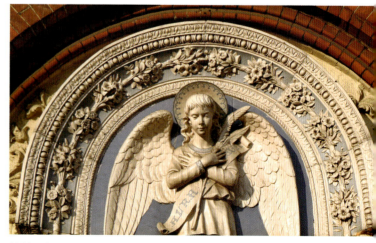

NOTICE THE DETAILS
This angel's decorative halo, along with the peaceful positioning of her hands, suggests a tranquil tone and creates a feeling of security.

AERIAL PERSPECTIVE

Creating convincing depth in a background—a principle otherwise known as *aerial perspective*—not only adds a level of realism to your paintings, but it also serves to reflect the emotional tone. Rather than relying on amorphous blobs of color or interesting textures for a neutral background, try playing with various types of settings.

For example, a walled garden with reflecting pools can add a sense of tranquility, while a figure surrounded by a dark forest suggests a somber mood. The possibilities are endless once you learn the basics of perspective and begin to think more about the details and moods of the scenes you wish to set for your characters.

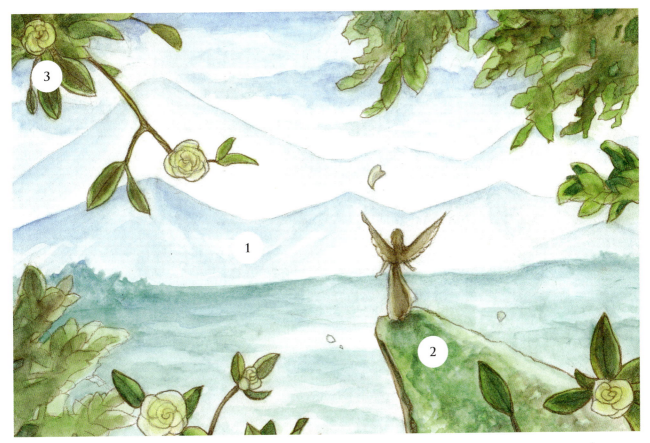

A SCENE IN PERSPECTIVE

An angel stands at the precipice of a majestic vista surrounded by blooming flowers. The distant mountains in the background add to the sense of awe in the angel's view.

1 BACKGROUND: According to the rules of aerial perspective (sometime called atmospheric perspective), objects in the far background are less detailed and often take on a hazy effect to imply that they are farther away. Because cool colors (blues, greens and purples) recede, try using colors such as Cerulean Blue for objects on this plane. You can see only the pale outline of the mountains in this painting.

2 MIDDLE GROUND: The middle ground is the space between the farthest objects in the image and the objects that are closest to the viewer's eye. Characters are often placed in the middle ground to accentuate their presence as the central focus of the scene. Details in the middle ground are generally well defined, though they may not be as in-focus as the foreground objects.

3 FOREGROUND: Objects in the foreground are closest to the viewer's eye and are in extreme focus, emulating the effect of a camera's lens. You can see more veins and creases in the leaves that are closest in the foreground.

LINEAR PERSPECTIVE

Linear perspective can add an even more convincing level of realism to your work. This technique is particularly useful for portraying architectural objects with many complicated planes.

ONE-POINT PERSPECTIVE

One-point perspective is the simplest form of this perspective system and is useful for keeping the objects in your images from looking warped or incorrectly distorted. As the name suggests, this form of perspective uses just one vanishing point, a point on the horizon where receding lines from the edges of all the objects' surfaces meet. Using this perspective system helps you to correctly suggest a convincing sense of volume in buildings, pillars and any other three-dimensional objects.

One-point perspective is effective for images that emphasize your character's relationship to a setting vanishing into the distance, perhaps to suggest longing or a tranquil moment of reflection.

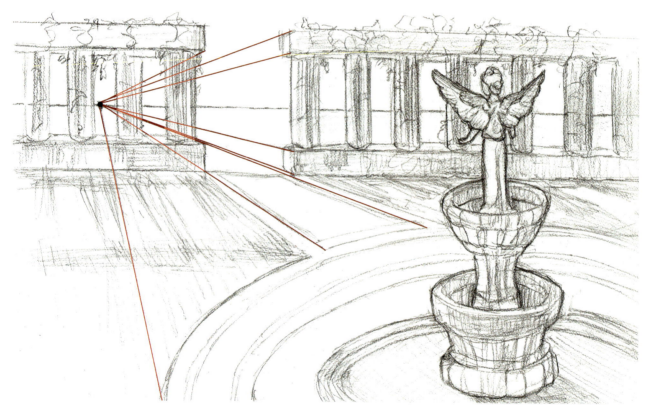

Perhaps your character is enjoying a peaceful visit to a garden or gazing across a misty landscape to the unseen adventures that lie beyond. Notice how the lines of the columns line up with the perspective lines leading back to the vanishing point. Also, because the angel statue is closer to the viewer, it is more detailed than the distant pillars.

TWO-POINT PERSPECTIVE

Two-point perspective uses two vanishing points where the lines that run parallel to your surfaces' edges meet. Unlike one-point perspective, this perspective comes into play when you are not looking at objects head on. It is one of the most common and natural perspective modes and works best for scenes that are on the eye level of the viewer.

Columns are especially mood-setting for tranquil courtyards and are an effective way to create atmosphere as well as emphasize distance and perspective because of the way they recede into the distance.

THREE-POINT PERSPECTIVE

The most radical of the basic perspective modes, three-point perspective uses three vanishing points, two on the sides and one on the top or bottom. Three-point perspective is used in cases where we are looking at an object from an extreme bird's-eye or worm's-eye view and is often used to suggest grandeur (i.e., viewing a building from street level looking up, or from above as if we were a flying bird).

SUGGESTED READING

Vanishing Point: Perspective for Comics from the Ground Up by Jason Cheeseman-Meyer

This bird's-eye-view perspective shows the grandeur of an angel-fortified castle in the sky.

CLOUDS

Heaven has long been associated with the splendid expanse of a blue sky filled with ethereal strokes of white. When it storms, it is said that the angels are bowling! It's no surprise, then, that clouds and angels make such good partners in artistic representations.

Clouds create an excellent neutral setting that add a light and airy appeal to any composition. However, clouds are not just random blobs. There are many different types of clouds, which can add interest and convincing depth and realism to your skies. Add the subtle presence of raised fluffy surfaces in the clouds rather than making flat areas of color. If you lose the edges of the cloud or want to add clouds to a wash of blue, try applying white gouache.

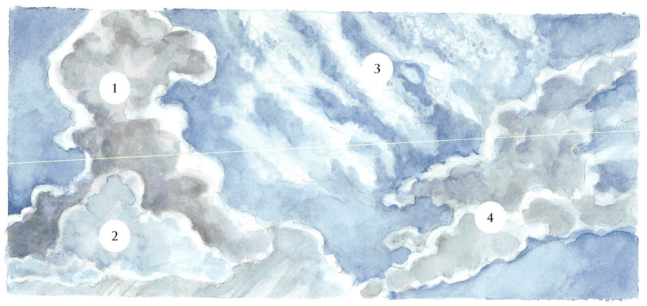

CLOUD TYPES

Besides being an excellent backdrop for neutral settings, clouds can also suggest tension in the atmosphere. A backdrop of boiling thunderheads ready to come alive with lightening and rain suggests danger on the horizon and elemental power. Remember that the color of clouds changes with the lighting throughout the day, which can also add mood and atmosphere to a scene. For example, clouds at sunset create a somber whimsical mood with their soft pinks, purples and yellows.

1 CUMULONIMBUS: These are the clouds you see during thunderstorms and are sometimes called thunderheads. They have high puffy peaks and are often gray and heavy with rain. Adding these clouds to your painting can suggest the onset of a storm and the dramatic lighting and energy that comes with a storm-lit setting. Try using Alizarin Crimson, Payne's Gray and Cerulean Blue when painting these clouds.

2 CUMULUS: If there's a generic type of cloud to paint, the cumulus cloud is it. It is a moderately puffy cloud that commonly forms during temperate conditions. These clouds make nice filler for a background when combined with other cloud forms. Try using layered washes of Cerulean Blue to render these clouds.

3 CIRRUS: Cirrus clouds are wispy, feather-shaped clouds that tend to form high in the atmosphere. Because they are made of ice crystals, they tend to have a grainier texture. Try using salt to give cirrus clouds a subtle texture. Also, keep your brushstrokes light and quick when painting the negative space around the clouds.

4 NIMBOSTRATUS: Nimbostratus clouds are another type of storm cloud. They hang low in the atmosphere and tend to spread out like a blanket across the sky. These clouds can add a solemn note to a composition when combined with a dark forest or other shadowy motifs. You can also play with the gaps in the clouds, allowing light beams to stream through from above. Payne's Gray and Cerulean Blue are good choices for rendering these types of clouds. A touch of Naples Yellow can add a particularly menacing tint.

FLOWERS

Like clouds, flowers also complement divine figures in marvelous ways. Besides adding a touch of grace and visual interest, flowers carry an inherent symbolism that most of us are familiar with on a subconscious level, even if we can't quite put our finger on specific meanings in everyday life. Each culture has its own tale of a flower's origin and meaning, making them an endless source of inspiration. In classical Western art, flowers were often used to convey symbolism without words, drawing on mythical stories and symbolic meanings from Greek and Roman traditions. Victorian society carried on this tradition of attaching meaning to specific flowers, ingraining their petaled symbolism deep within Western culture.

Think about how flowers might inform your figures, and how they can help you tell your own stories. The white lily speaks of an angel's innocence and purity, while the dark petals of the deadly nightshade sprout from the body of the Archangel of Death, indicative of his connection to the taking of life and divine beauty. Where the white roses grow, a glimpse of divinity might be revealed. After studying lore, reading, writing and painting, these themes found their way into my work until my ideas resonated with the stories I wanted to tell through drawing and painting. With study and the constant nurturing of your own visual and literary vocabulary, you can form your own connections between the figures you draw and the visual elements and objects that work best to convey them.

START WITH SIMPLE FORMS

The complicated shapes of flowers can be broken down into simpler abstract forms that are easier to draw and less intimidating. Once you become more familiar with the forms of flowers, you can be more creative with the abstractions of their shapes. A stylized rose can be used to create a dazzling stained glass window or the repeated pattern in a trim on a lovely dress.

USE ABSTRACT SHAPES FOR INSPIRATION

In addition to being useful for learning how to draw flowers, simplification of the flower into abstract shapes can also give us ideas for creating decorative motifs for stained glass, wardrobe design, stone carvings and countless other elements.

SUGGESTED READING

- *Flowers, the Angels' Alphabet: The Language and Poetry of Flowers* by Susan Loy
- *Treasury of Flower Lore* by Josephine Addison

demonstration:
PAINTING A SINGLE FLOWER: ROSE

The rose is an immortal symbol of love and beauty. Roses come in an endless variety of colors, making them the perfect accent to any image and a powerful way to accentuate the presence of an angel.

MATERIALS

WATERCOLOR PIGMENTS

Cadmium Yellow, Burnt Umber, Perylene Maroon, Sap Green

OTHER SUPPLIES

Eraser

Pen

Pencil

Paintbrush

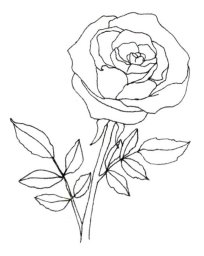

1 Draw the Basic Shape
Using a pencil, draw a spiral form for the flower and straight lines for the branches of leaves.

Start in the center of the bloom and work outwards, adding petals as you go. Draw the stems and leaves (one leaf at the top of each branch and two leaves on each side). Then, use a pen to ink the form, erasing the pencil lines after the ink has dried.

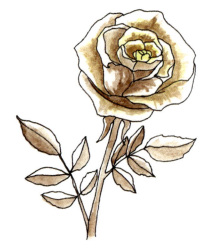

2 Begin Coloring
Color the center of the petals with Cadmium Yellow. They have a stronger yellow tint towards the heart of the rose. Drybrush the main shadows of the petals using Burnt Umber, emulating a rose petal's subtle textures.

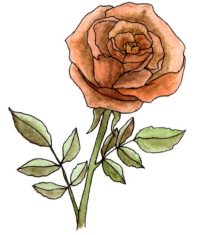

3 Add the Base Tones
Lay in the base tones of the rose petals with Perylene Maroon and the stem and leaves with Sap Green.

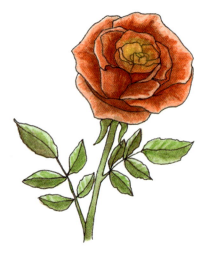

4 Finish the Flower
Layer dry-brushed strokes of Perylene Maroon within the petals. Add subtle veins to the leaves with dry-brushed strokes of Sap Green. Swipe prominent strokes with a clean damp brush to take away harsh edges. Redefine the yellow with a final touch of Cadmium Yellow at the center of the rose's heart.

demonstration:
DRAWING A CLUSTERED FLOWER: HYDRANGEA

Some of the most exotic and eye-catching flowers are made from clusters of smaller flowers. These present a more complicated subject to draw, but are not that different from drawing basic flowers once you break down the main shapes.

MATERIALS

COLORED PENCILS

Cloud Blue, Dahlia Purple, Dark Green, Light Cerulean Blue, Spring Green, White

OTHER SUPPLIES

Eraser

Pencil

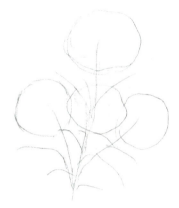

1 Draw the Basic Shape
Break down the form into basic shapes, using circles for the clusters and lines for the stems and leaves.

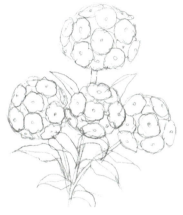

2 Add Defining Details
Indicate individual flower petals in the cluster. Draw the leaf shapes and add the main veins in the leaves.

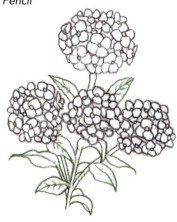

3 Outline the Shapes
Using Dark Green and Dahlia Purple, outline the major shapes of the hydrangea.

4 Begin Coloring
Color the blossoms with a light layering of Dahlia Purple and Light Cerulean Blue. Layer the Dahlia Purple thicker in the shadows.

Add shadows on the stems and flowers with Dark Green, gradually increasing the pressure of the pencil strokes. Add touches of Dark Green to the gaps between the flowers.

5 Finish the Flower
Continue building up the leaf color. Then, burnish the stems and leaves with Spring Green, using White for the highlights. Use Cloud Blue to burnish the flower cluster's shadows, using White to blend the rest. Use Dahlia Purple to outline the stems and leaves, tying them in with the petals.

TYPES OF LEAVES

Leaves can be variegated, three-pronged, veined and more. Study plant life to learn about their varieties. Varying your plants can help make your image truly shine.

Watch Angela in action at: http://AngelicVisions.artistsnetwork.com 65

STONE TEXTURES

Stone need not be a continuous swath of gray. Study local churches, cemeteries and old buildings to get a sense of how varied stone surfaces can be. From granite to the many types of marble to sandstone, the possibilities are endless.

Marble and white stone especially lend themselves to the otherworldly subject of angels. A change in the stone surface color can add a variety of moods to your scenes. Red stone may suggest passion or violence, while cold, white, weathered stone can suggest peacefulness and wisdom.

ROUGH STONE

To achieve rough stone, use wet-into-wet techniques to drip color onto the surface. Apply splatter with a toothbrush or sponge to suggest texture. Then use a sponge or brush to lift color and create highlights. The more layers of texture, the older and more weathered the stone will appear.

DARK MARBLE

Apply a wash of Viridian and Payne's Gray. Create extra texture and shadows by splattering Payne's Gray and Viridian into the damp wash. To create white veins in the marble, streak alcohol across the surface with a fine brush (or use white gouache or colored pencil). Add the black veins with an ink pen or by drybrushing Lamp Black with a fine-tipped brush.

LIGHT MARBLE

Add streaks of Ultramarine Blue and Raw Umber to form the bruises of color within the white marble in a wash. Once this layer is dry, remoisten the surface and add darker veins of Sepia with a fine-tipped brush. Because the surface is wet, the veins will fray out slightly.

CREATING WEATHERED STONE

1 To age the appearance of your stone, try adding ivy. Ivy grows in sweeping curves of foliage that cling to the cracks in stone, creating a mood of timeless elegance. The variegated patterns of the leaves can also be manipulated to accent other colors within your image.

2 Adding cracks to your stone surface can also suggest that it has weathered the ages, like the walls of an ancient temple or a forgotten sacred place. Remember not to make your cracks too uniform, or they won't look convincing. Photographic reference is especially handy for preventing this sort of issue.

3 Consider adding moss to further date your stone structure. Moss forms a speckled blanket that covers stone, suggesting it has been left to the mercy of the elements. Splatter Sap Green with a toothbrush and add salt texturing to create the effect of mossy growth. Thicken the moss to obscure the surface completely to age the appearance even more.

demonstration:
SUGGESTING STONE

The weathered edifices of stone are famous backdrops for angelic figures. The presence of time-kissed rock can add a sense of splendor to your angelic portrayals.

1 Sketch and Apply a Wash
Sketch in the stone cracks, creating a squared-off organic pattern typical of stone surfaces. Use a 1-inch flat (25mm) to lay down a diluted wash of Ultramarine Blue and Burnt Umber. Don't worry if the colors start to separate on your painting, as stone is naturally mottled in most cases.

2 Add Shadows and Texture
Using a no. 00 round and a concentrated mix of Ultramarine Blue and Burnt Umber, drybrush the texture and shadows in the stone. The more rugged the shapes, the better. For a smoother look, blend the edges of the shadow with a damp brush. Leave a lip of highlight around the edges of the cracks to suggest raised edges.

3 Increase the Color Intensity
To increase the color intensity, use your 1-inch (25mm) flat to lay down a diluted wash of Ultramarine Blue and Burnt Umber. If the shadows become indistinct, pop them back out again by repeating step 2.

4 Suggest the Cracks
For the final effect, use a no. 00 round and a concentrated mixture of Ultramarine Blue and Burnt Umber to draw in the cracks. Add accents of Lamp Black into the deepest parts of the cracks.

Watch Angela in action at: http://AngelicVisions.artistsnetwork.com 67

demonstration:
DEPICTING STAINED GLASS

In the dim interior of sacred places, a jeweled light shines bringing comfort, warmth and inspiration to those inside. Like angels themselves, stained glass is lit from within by a brilliant radiance, making it a perfect complement to these winged beings.

MATERIALS

WATERCOLOR PIGMENTS

Alizarin Crimson, Cadmium Red, Cadmium Yellow, Cerulean Blue, Lamp Black, Payne's Gray, Sap Green, Viridian

OTHER SUPPLIES

nos. 00 and 2 rounds

Pen (0.3mm) with black ink

Pencil

Plastic wrap

Ruler

1 Draw the Design
Sketch the design for the stained glass in pencil. Most stained glass designs are geometrical, so you may need a ruler or a graph to keep your shapes uniform. You can also use a computer to copy and paste sections of your design, then print and transfer the design onto the painting surface.

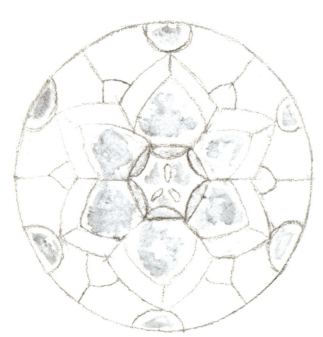

2 Apply the Basecoat to the Central Design
Using a no. 00 round and Payne's Gray, paint in the center of the narcissus flower and the white accents on the outer edge. While the paint is still wet, lay a piece of plastic wrap over the area and let it dry. Once the paint is dry, remove the wrap to reveal an interesting subtle texture for your stained glass.

3 Layer With Blue
Emphasize the texture and add color variation in the gray areas using a no. 00 round and hints of Cerulean Blue. The blue adds a cool yet vibrant touch to the Payne's Gray.

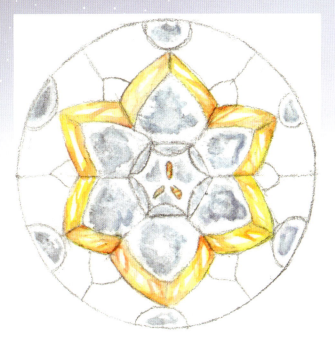

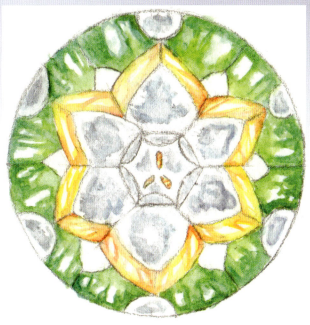

4 Add the Gold Border
Paint the border around the narcissus using a no. 00 round and Cadmium Yellow. While the paint is still wet, add a touch of Cadmium Red to the corners for color variation. Leave strong white highlights to imply light rippling through the glass.

5 Paint the Green Sections
Drybrush a layer of Sap Green using a no. 2 round, leaving strong highlights for the rippled light effect. While the layer is still wet, use a no. 00 round to add touches of Viridian on the outside edges and hints of Cadmium Yellow near the center.

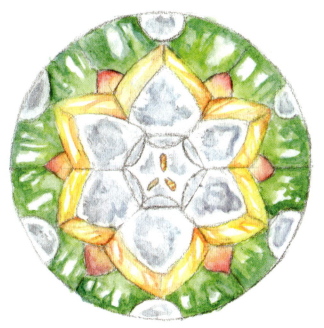

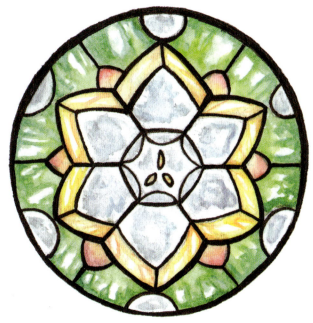

6 Place the Red Accents
Finish by painting in a flat area of Alizarin Crimson using a no. 00 round. Blend in Cadmium Yellow while the paint is still moist to create a yellow glow.

7 Outline the Forms
For the final touch, draw the dark lead outlines with a 0.3mm black ink pen. Alternatively, you can use a no. 00 round and Lamp Black for a less intense outline.

demonstration:
ANGEL OF PURITY

Amongst the lilies, she is the touch of white that flashes in the sun, her breath the soothing fragrance that calms the saints. She lives for the moment of a flower's brief life, only to be reborn anew with the opening of each blooming bud.

Now you're ready for a practice run. Use your knowledge of creating figures and setting the scene to paint the Angel of Purity.

1 Paint the Background
Lay a wash of Cerulean Blue into the background with nos. 2 and 4 rounds. While the wash is still damp, sprinkle table salt in key locations to create a sweeping starburst effect. Remember to wipe away the salt after it dries.

2 Begin Coloring the Figure
With a no. 2 round, add subtle hues to the skin, cheeks and lips with light washes of Rose Madder. Lay in touches of Cerulean Blue to the eyelids using the same brush. Apply light washes of Naples Yellow to the wings, and add Burnt Umber towards the tops to create the subtle shift in the feathers' color. Then, add a blend of Cerulean Blue and Ultramarine Violet to the crevices of the white cloth and a touch of Lemon Yellow to the centers of the lilies.

3 Add Shadows
Still using a no. 2 round, lay in a wash of Ultramarine Violet to create shadows in the skin. Use Burnt Umber to detail the feathers in the wings and add shadows to the lily stems. Add deep shadows to the folds of the cloth in the white drapes and the sweeping lines of the hair using Payne's Gray.

4 Apply the Midtones
With a no. 4 round, apply a diluted wash of Yellow Ochre and Cadmium Red mixed with a dab of Chinese White to the skin. If the purple shows through too much, wait for the layer to dry and apply successive layers of the Yellow Ochre and Cadmium Red mix until you reach the desired skin tone.

Using the same brush, add the midtones of the hair with Van Dyke Brown. Again, if the underpainting seems awkward, apply successive layers of the midtone color to smooth the blending. Pick out the details of the sheer shawl with Cerulean Blue, and add color to the lily stems, buds and stamens with Sap Green.

Then using your no. 2 round, add a touch of shading to the lips with Burnt Umber.

COLOR TEST

Before you begin any painting or drawing, it's important to perform a color test. Once you've completed your pencil sketch of the subject, scan it into your computer and use a photo editing program such as Adobe® Photoshop® or GIMP to fill in the base colors. This will give you an idea of which color palette works the best. This color test is called a *color composition*.

Establishing your colors and lighting early on can save you time and heartache in the long run. Finding out at the end that you really don't like the colors you used can be very disappointing!

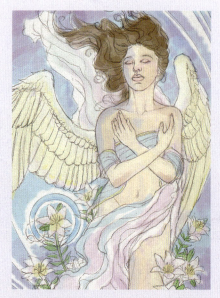

For this painting, I chose a cool color palette with dark brown hair to emphasize the subtle warmth in the flowers and skin.

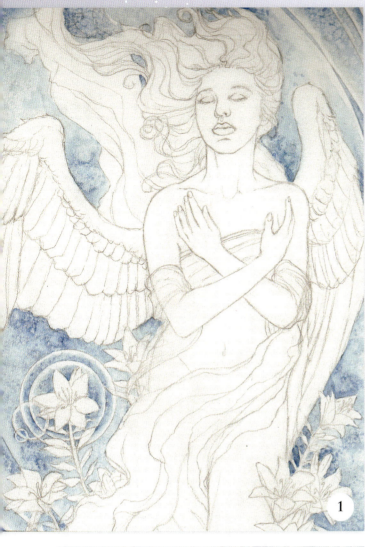

1

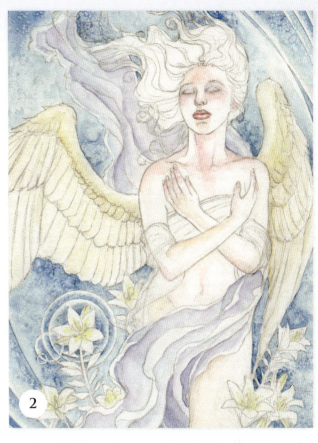

2

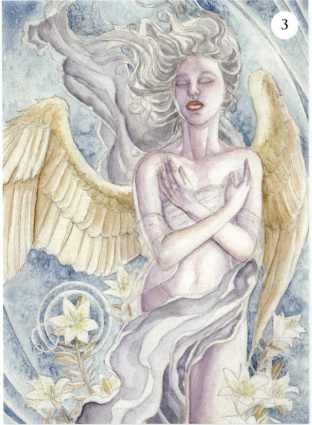

3

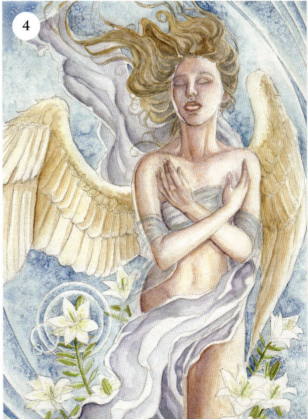

4

5 Suggest Backlighting and Adjust Shadows

Using a no. 2 round and Light Cerulean Blue, indicate backlighting behind the figure, cloth, wings and flowers. Use the same brush loaded with Payne's Gray to detail the lilies. Emphasize the deepest shadows in the hair and skin using Burnt Umber and a no. 3/0 round. The shadows tend to be most intense where the blue rim lighting overlaps with the shadows on the skin.

6 Outline the Main Elements and Add Finishing Touches

Make the lines of the image pop by using your no. 18/0 round to detail the main elements of the drawing. Use Payne's Gray to outline the shawl, flowers and flowing white cloth. Pluck out the main shapes of the hair and feathers, outlining them with Burnt Umber. Continue outlining the lips with Burnt Umber to emphasize their full shape and subtle texture. Finally, finish the flowers by speckling the petals with a stippling of Burnt Umber. Add small dabs of Burnt Sienna to finish the stamens.

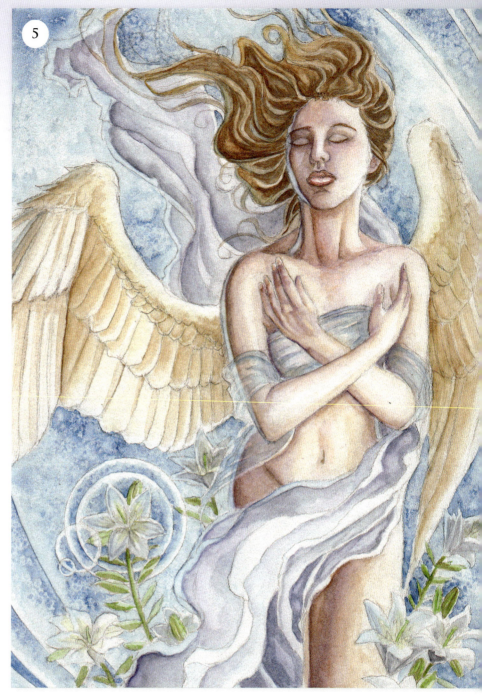

RIM LIGHTING

Rim lighting refers to the rim of light around the outside edge of an object which is generally caused by a light source from behind or from light reflecting off of objects nearby, creating a rim of light. Rim light also helps to separate the subject from the background and is often used in photography to make sure the subject isn't lost to dark shadows that blend with a dark background.

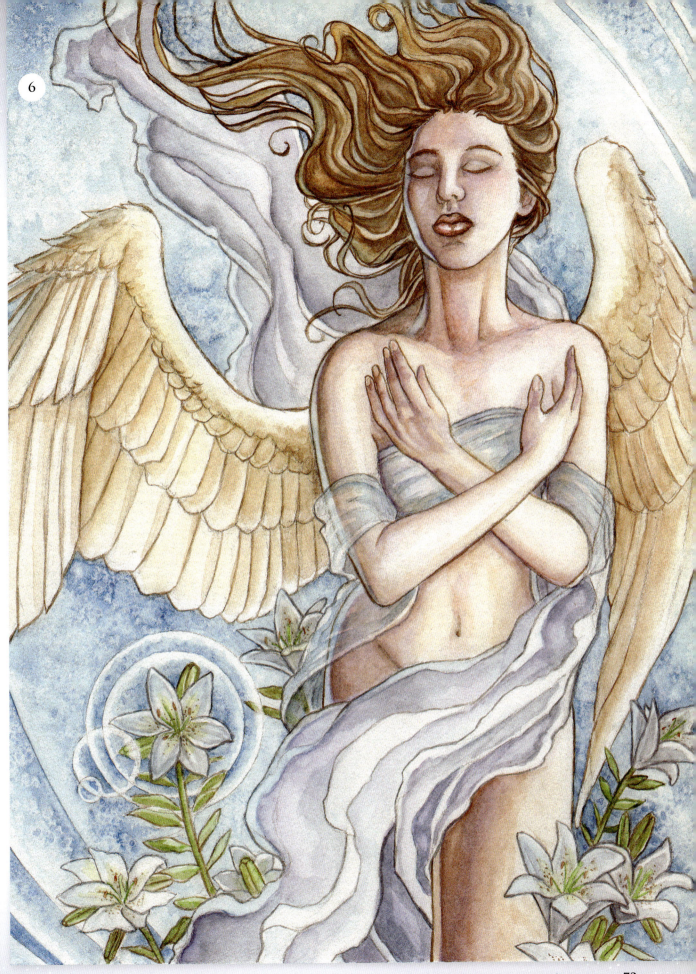

6

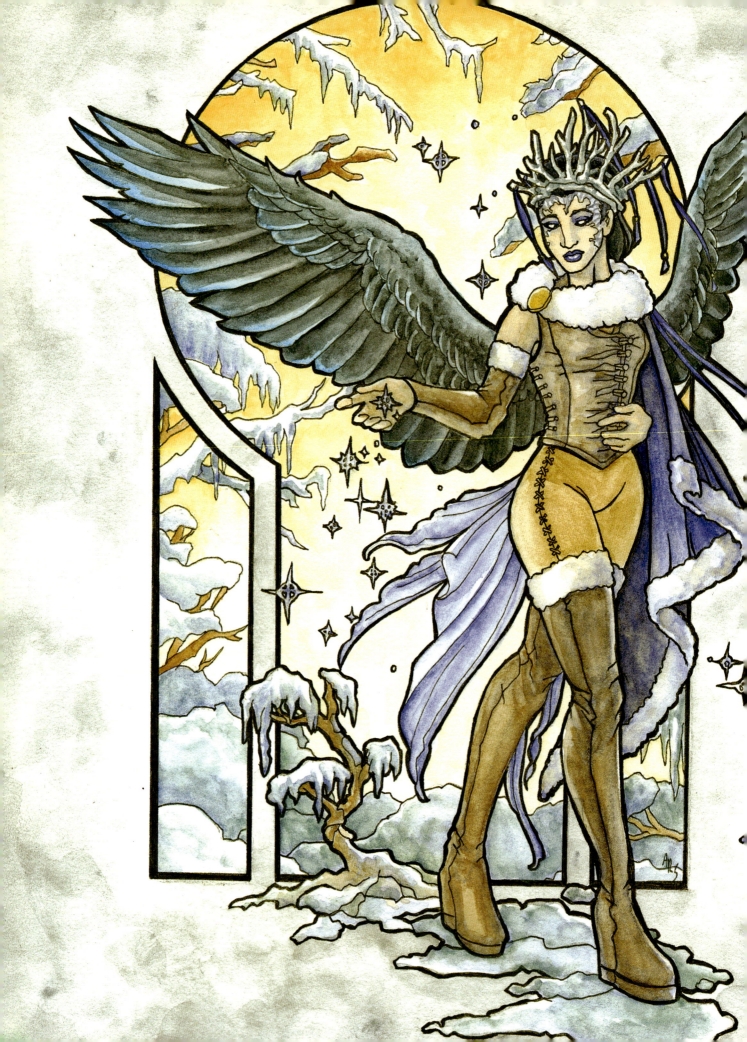

chapter four
CREATING ANGELIC VISIONS

YOU'VE BRAVED THE RIGORS OF CHARAC-TER DESIGN and started gathering ideas for your settings. Now the real fun begins— you are ready to tackle your completed concept with color!

This chapter is about putting everything you've learned in the previous chapters to the test by going through several walk-throughs that feature each of the various angelic archetypes: the Muses, the Guardians, the Rebels and the Archangels. You will also be given a glimpse of how you can employ a combination of various media to communicate specific moods and textural effects. Don't stop there, though; continue reading other art books. The methods presented here are but a basic few, and the possibilities are endless when it comes to experimentation.

Let fly the spirit of adventure and jump headlong into creation with me!

ANGELIC CHARACTERS

For the purposes of the following lessons, I've broken down the angelic types into four archetypes: the Muses, the Guardians, the Rebels and the Archangels. It's important to remember that all angels are not the same. You need not constrain yourself to portraying only one type, nor even four. I chose four to represent the basic moods most prevalent in angelic depictions. The possibilities are as limitless as your ability to create unique characters. These archetypes are guidelines only, not concrete truth.

THE MUSES

Invoked by artists throughout the ages, the exuberant spirits we call *muses* have forever existed in the shadows of the unformed idea. They whisper their secrets and wait for us to listen. They are the distracting urge of the three A.M. painting session or the subtle tickle of a poem as we stare at a sunlit garden. A muse is creativity incarnate and, perhaps, the most elusive and sought-after of the angelic spirits. Muses represent the most classical archetype of the angel, the graceful ephemeral creatures that conjure all we remember in stories about divine inspiration and angelic generosity.

THE GUARDIANS

It is said that even the tiniest blade of grass has an angel watching over it. The guardians are the protective spirits of mankind, the invisible presence that comforts you on a lonely night or who inspires you to find your way when you are lost.

A guardian exists even for the most insignificant creatures that form a part of the beautiful tapestry of Creation.

Guardians are the angelic archetype most colored by the presence of a core concept outside of themselves. They inherently exhibit the characteristics of the thing or person they protect, and reflect that which their protectorate most longs for. Often, guardians make for fitting tragic figures, should the person they are bound to guard reject them or seek to connect with them in forbidden ways.

THE MUSE
Muses work well when depicted in the Classical body type in settings that emphasize their link to the arts and nurturing growth.

THE GUARDIAN
The most important thing to consider when drawing a Guardian is how to suggest the character's relationship to what he or she is protecting, which adds a particular resonance to this angelic archetype.

THE REBELS

They are the passionate warriors, the unstoppable slayers, and sometimes, they are the fallen. Unlike their glorious counterparts, the rebels find inspiration and compassion to be less effective than the blade in the hand or the arrow in the notch. They are fearless in the face of evil, unyielding in the presence of an enemy and defiant of the peaceful ways of other angels. Being so close to the creatures they hunt, they are at times the first to fall from divinity.

I often choose to depict this archetype with tattoos, war paint, and wildly flowing hair to emphasize their physicality and bold personalities. Other ways to suggest their link to the mortal realm is by humanizing them with scars, war wounds and other marks that mar the perfection of what would otherwise be tidy divinity. Rebels work well in settings that connect them with the mortal plane (i.e., wild forests, forbidden ruins and shadowy crossroads).

THE ARCHANGELS

In the highest spheres of Heaven, these princes amongst angels lead the heavenly hosts. In fact, their very names are the battle cries of other angels. They lead where others might follow and show compassion where others are merciless. There is no need to fear when there is an archangel amongst us.

Archangels represent another familiar archetype we often associate with the ultimate pinnacles of morality and loyalty to their duties as agents of divine will. They are the angels that take action, the champions of the many and of the few.

THE REBEL
Disorderly and free-willed, Rebels are never as stiff or morally bound as their Archangel opposites.

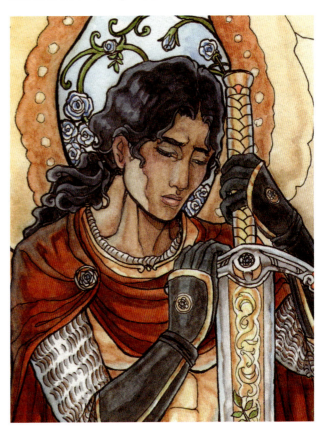

THE ARCHANGEL
The Strong body type easily intimates the power of these tremendous beings.

THE MUSES:
A DEMONSTRATION IN WATERCOLOR AND COLORED PENCIL
VERDANT MUSE

Muses are not consigned to inspiring poets and musicians. The dying oak, endued by the presence of a divine muse, becomes home to the blooming mushroom and the climbing wild rose. Those who sense her presence have left the gift of jewels and stones in hopes that she will return once more to bring life to their sacred arbors.

The colored pencil in this tutorial helps to bring a creamy, slightly textured depth to the angel's skin tones while also allowing you to bring in the deeper tones of a twilight scene which casts a subtle glow on the skin.

1 Create the Vibrant Sky and Misty Hills
Sketch the drawing, then lay in the sky and hills with a wash of Cerulean Blue using a no. 4 round. Leave the area around the angel's halo pale. Blend the edges, lifting with a paper towel and pulling and blending the color with a clean, damp brush.

Once that layer is dry, lay in an extra-moist wash of Cobalt Blue. Sprinkle salt in random spots around the skies to create cloud texture. Remember to wipe away the salt after it is dry.

2 Add the Verdant Midtones
Using a no. 4 round and a mixture of Burnt Umber and Burnt Sienna, paint in the ground soil using wet-into-wet techniques. Concentrate the Burnt Umber near the top of the ground section to imply depth. Using the same brush, add a wash of Sap Green into the background hills and the grass and bushes near the angel.

3 Vary the Hues in the Foliage
Using wet-into-dry techniques, add variation to the green in the foliage nearest the angel with a no. 4 round. Add Viridian into the ground as well, bearing in mind the subtle slopes and rocks in the soil.

4 Add Detail to the Foliage and Soil
Use a no. 2 round and Viridian to drybrush in the details of the soil, brush and grass. Accentuate the irregularities created by the way the colors have layered over one another, and draw round, leaf like organic shapes.

5 Lay In the Tones of the Tree and Rocks
Use a no. 4 round to apply a wash of Light Red for the first layer of color in the tree and roots. Allow this to dry, then use a no. 2 round and a mixture of Brown Madder and Payne's Gray to drybrush textured shadows. While you paint the shadows, bear in mind the twisting nature of the tree's trunk and the rough chunks of tree bark.

With the same brush, apply a wash of Brown Madder mixed with Payne's Gray to the rocks. Use loose strokes to simulate the varied texture of a rock surface.

MATERIALS

WATERCOLOR PIGMENTS

Brown Madder, Burnt Sienna, Burnt Umber, Cadmium Yellow, Cerulean Blue, Cobalt Blue, Light Red, Payne's Gray, Perylene Maroon, Raw Umber, Sap Green, Van Dyke Brown, Viridian, Yellow Ochre

COLORED PENCILS

Blush Pink, Canary Yellow, Celadon Green, Crimson Red, Dark Umber, Light Peach, Peach, Pink Rose, Pumpkin Orange, Sand, Sienna Brown, True Green, Tuscan Red, White

OTHER SUPPLIES

nos. 00, 2, 4 rounds

Pencil

Table salt

1

2

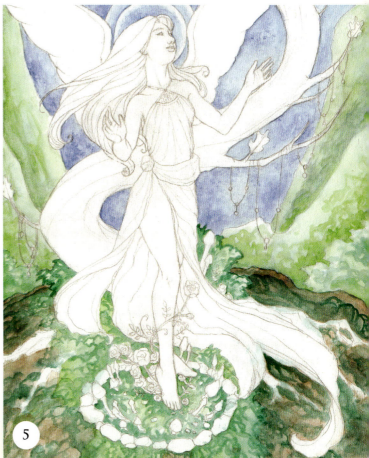

3

4

5

6 Finish the Tree and Suggest the Leaves, Mushrooms and Rocks

Using a no. 00 round and Burnt Umber, emphasize the texture in the tree trunk and roots. Add knots and sections to the bark to make it more convincing. Color in the leaves with a no. 2 round and Sap Green. Add a touch of Raw Umber to the centers of the leaves while the paint is still wet. Then, accent the mushrooms with a light wash of Yellow Ochre.

Using a no. 00 round and Payne's Gray, add detail to the rocks and accent the planes of the stones with light hatching. Outline the mushrooms and oak leaves with the same brush and Burnt Umber.

7 Paint the Clothing and Wings

Using a no. 4 round, apply a wash of Cadmium Yellow to the angel's body, wings, halo and clothing. Keep the core of the wings white to imply the glowing light coming from within.

Finish the wings with a wash of Burnt Sienna in the shadows, then add Burnt Umber details and accent lines using a no. 00 round.

Then with a no. 2 round, add shadows to the hair using Payne's Gray and to the angel's clothing using Burnt Umber.

8 Color the Clothing and Hair

Using a no. 4 round, add a wash of Van Dyke Brown to the hair and Perylene Maroon to the dress. Once the wash layer is dry, darken the shadows with successive layers of the same color and smooth the blending of the shadows with a no. 2 round.

9 Outline the Major Forms

Make the figure pop out from the background by using a no. 00 round to outline the dress and hair in Burnt Umber. Next, switch to colored pencil and outline the figure and rose vine with Dark Umber. Use this outline as your guide to prevent your pencil lines from getting lost.

Continuing with colored pencils, apply a light layer of Celadon Green to the skin, adding Canary Yellow over the yellow rim lighting. Fear not! The green in the skin keeps the angel from looking too orange once you apply the later hues. It won't look so horrible later on.

10 Place Accents and Shadows on the Skin

Accent the skin with Blush Pink. Add touches of Crimson Red to the shadows of the nose, lips, fingers, palms, knees, toes and elbows. Add a touch of Pumpkin Orange to her forehead and shoulders. Keep the colored pencil layers light and evenly distributed as you work. It helps to overlap the layers with slightly different intersecting motions as you color.

Apply a layer of Sienna Brown to create the shadows of the skin. Add a touch of Dark Umber to the deepest part of the shadows.

11 Add Midtone to the Skin

Apply the midtone layer of the skin with Peach. Layer more lightly over the highlight areas, such as the middle of the thigh. Throughout the process of adding the skin's base tones, do not color over the rim lighting area, as it needs to remain in bright contrast with the rest of the skin.

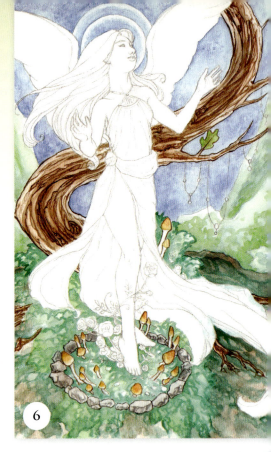

6

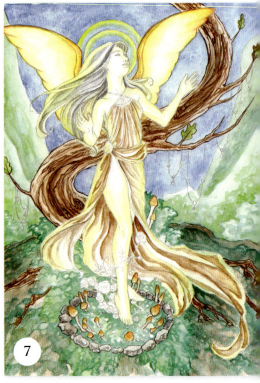

7

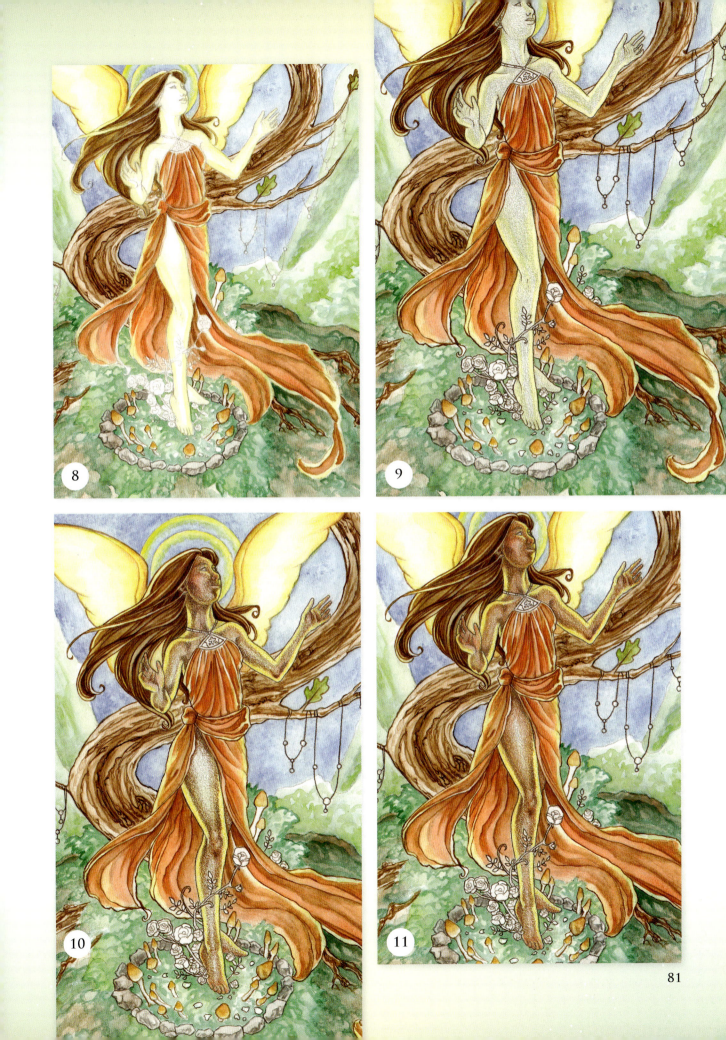

12 Smooth Out the Skin Colors

Now that you've applied the base tones and built up the colored pencil layers to nearly saturate the paper, smooth out the skin colors by burnishing with Light Peach. Use White to emphasize the highlights and to blend the rim lighting so that none of the paper texture shows through. It's not necessary to press hard to smooth the colors. Merely apply the Light Peach with a moderately firm hand, layer after layer. If you begin to lose some of the shadows, pull them out again with the Sienna Brown, then smooth once more with Light Peach.

13 Color the Roses

Start by laying in the golden center of the roses with a layer of Canary Yellow, then add the layers of shadow in the petals with Tuscan Red. Use Dark Umber to add the shadows of the stems and leaves.

14 Continue Refining Details

Use Dark Umber to lay in the shadows of the hanging jewels and the angel's necklace.

Burnish and smooth the colors in the roses by adding Pink Rose. Use True Green to smooth the colors in the stems and leaves.

Add Crimson Red to accent the jewels in the necklace and those hanging from the tree.

15 Add the Finishing Touches

Finish the necklace by burnishing with Sand and White. Burnish the hanging jewels with White to add the slight gleam to them.

Give the picture one last look over to make sure there aren't any white spaces or sloppily blended areas between the colored pencil and watercolor sections.

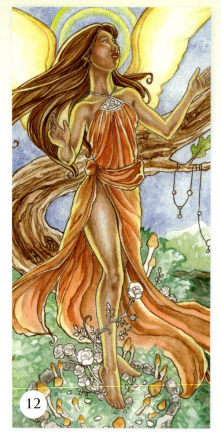

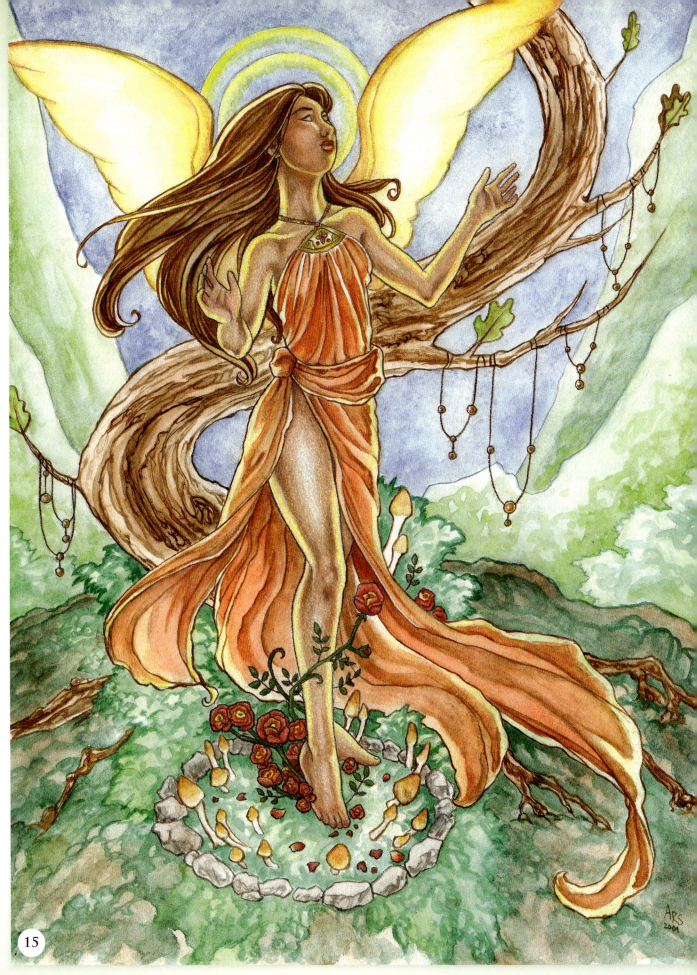

15

MUSE OF THE UNDISCOVERED

How many ideas are there that you haven't thought of yet? How many ideas have come to you, but you haven't had time to realize them? How many ideas do you entertain and immediately dismiss? How many ideas will you not be able to bring to fruition in your lifetime? The Muse of the Undiscovered awaits, guarding each unclaimed idea and hoping for the day it sees life.

1 Ink the Sketch
Use a 0.1mm nib for most of the lines. Draw delicate details, such as the roses and candles, using a .005mm nib. Fill in the large areas of black with a no. 4 round dipped in black waterproof ink.

2 Paint the Windows
Once the ink is thoroughly dry, lay in a wet application of Cerulean Blue using a no. 2 round. While your surface is still wet, press a crumpled piece of plastic wrap into the paint to create texture. Once dry, remove the wrap to reveal the results.

3 Color the Bookshelves and Tables
Working with the background first, apply a base wash of Sepia to the bookshelf with a no. 2 round. Once this layer is dry, apply another layer to darken the crevices of the bookshelf, giving the object more volume. Use the same size brush to apply a wash of Van Dyke Brown to the tables. Carefully paint around the halos of the candles as you go. If you paint too closely to the halos, swab a circle around the flames to lift out color and create soft color shifts.

Using a no. 2 round, drybrush a light wash of Payne's Gray into the tables to create the wood grain pattern and shadows.

4 Add Shadow Accents
Painting wet-into-dry, use a no. 3/0 round and Raw Umber to add the shadow accents to the gold trim of the table, the vase and the books.

MATERIALS

WATERCOLOR PIGMENTS

Burnt Sienna, Burnt Umber, Cadmium Red, Cadmium Yellow, Hooker's Green Light, Lemon Yellow, Cerulean Blue, Light Red, Naples Yellow, Payne's Gray, Perylene Maroon, Prussian Blue, Raw Umber, Rose Madder, Sap Green, Sepia, Ultramarine Violet, Van Dyke Brown, Yellow Ochre

OTHER SUPPLIES

Eraser

nos. 3/0, 2 and 4 rounds

Pencil

Pens (0.1mm and .005mm)

Plastic wrap

Waterproof black ink

CHOOSING A MEDIUM

I decided to use pen and ink with watercolor for this project. Notice how the dark ink offers high contrast to the softer watercolor, allowing the image to take on the mood of a stained glass window. With the very dark blacks and sharp contrast of the ink, it's easier to emphasize the soft glow of the candles and her wings, which will be the brightest objects in the composition.

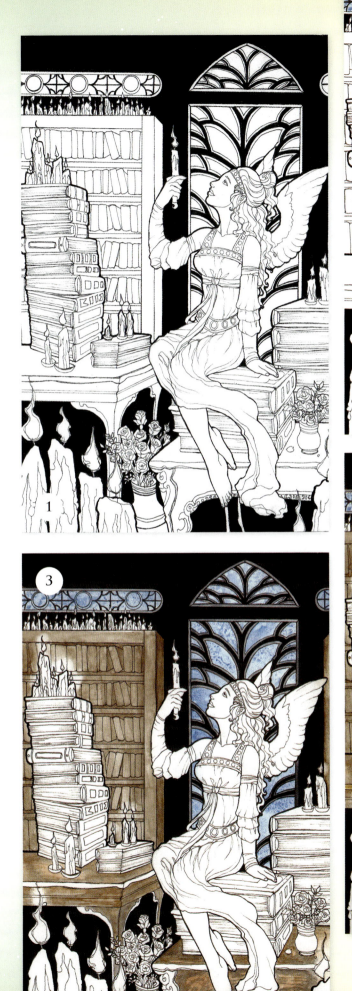
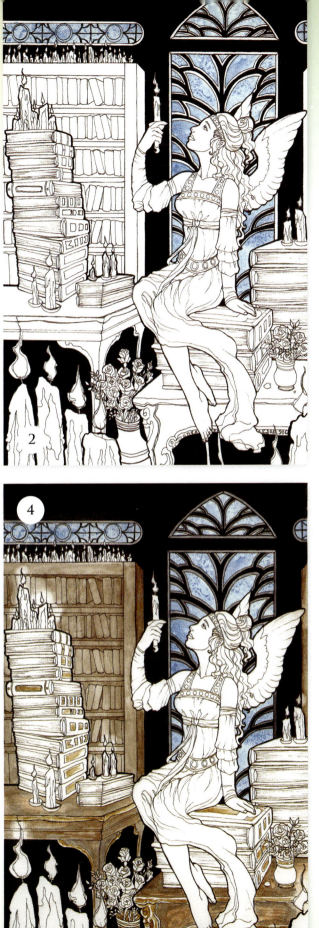

5 Add Basecoat to the Books, Vases and Candles

Using a no. 2 round, add a wash of Naples Yellow to the pages of the books, vases and candles. Leave an area of white near the tips of the candles to emphasize their semi-opaque nature.

Using nos. 2 and 3/0 rounds, add the shadows of the books in Burnt Umber. Add a glint of shadows into the candle holders using a no. 3/0 and Van Dyke Brown.

6 Continue Developing Base Colors

Paint a light wash of Naples Yellow into the angel's dress and wings with a no. 4 round. The touch of yellow in her dress adds a natural tone and glow.

Use a no. 3/0 round to add Payne's Gray to the shadows of the book pages. Keep your strokes light and linear.

Add a touch of Rose Madder to the angel's skin and lips with a no. 2 round. Then, add glinting shadows to her hair broach using a no. 3/0 round and Van Dyke Brown.

7 Paint the Books

Using a no. 2 round, apply washes of Hooker's Green Light, Burnt Sienna, Perylene Maroon and Prussian Blue to the books. If the Burnt Umber of the shadows shows through, continue adding washes until the shadows are adequately smoothed out.

8 Place Various Shadows and Accents

Using a no. 3/0 round and Burnt Umber, add shadows to the roses, the dress trim, the wings and the main part of the vases. Make the shadows on the vases loose and blotchy to convey a beaten gold texture.

Accentuate the curls of the angel's hair using a no. 0/3 round and Burnt Umber. With the same brush, color in the stems of the roses with Sap Green.

9 Finish the Roses

Using a no. 3/0 round, apply layered washes of Perylene Maroon to complete the roses.

10 Lay in Shadows on the Skin

Create shadows on the skin using a no. 2 round and Ultramarine Violet. She may look like a purple people eater right now, but this will change with subsequent layers of color.

11 Refine the Skin Tone

Using a no. 2 round and a mixture of Cadmium Red and Yellow Ochre, paint the skin until it is smooth and not too purple. Let the layers dry between applications. Continue adding the warm brown tones of her skin using a no. 0/3 round and Burnt Umber.

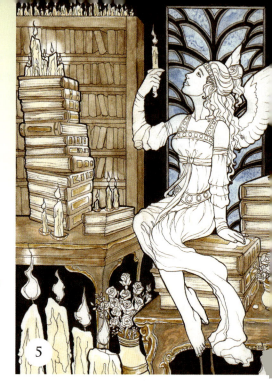

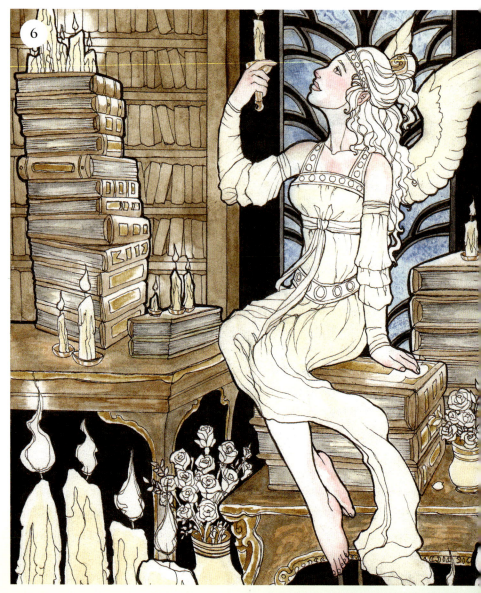

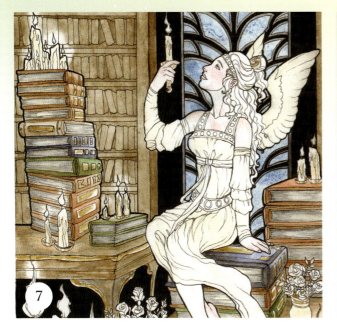

7

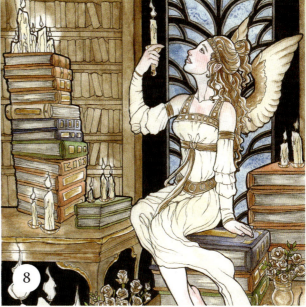

8

9

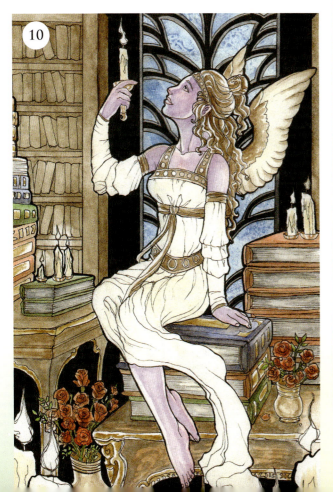

10

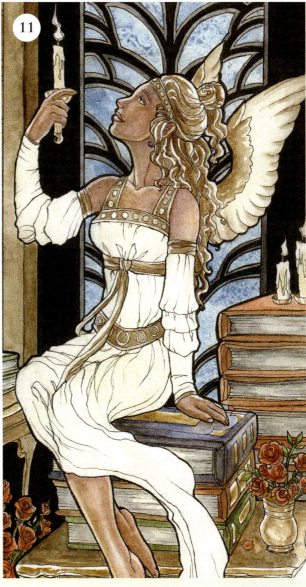

11

12 Add Remaining Details

Finish the dress trim, book decorations, vases, candle holders and the decorative edges of the table with washes of Lemon Yellow, using nos. 2 and 3/0 rounds as needed. Define the wrinkles of the dress with a gray mixture of Payne's Gray and Naples Yellow.

13 Finalize the Hair and Wings

Add the tones of her strawberry red hair using a no. 2 round and washes of Light Red. Create the golden glow of the wings by defining them with Cadmium Yellow. Leave a strong, white highlight.

14 Add Finishing Touches

Using a no. 2 round, add touches of Payne's Gray to bring out the texture in the dripping candle wax. Leave the tips of the candles white to suggest the bright glow of the flame near the candle wick.

Continue using a no. 2 round to complete the glow of the candles. Color the halos around the flames with Cadmium Yellow. Trace the rim of the figure with Cadmium Yellow to suggest the glow from the candles being cast against the figure's skin. Give the books beneath the candles a glow or perhaps a hint of blue reflected light, filtering in through the stained glass window.

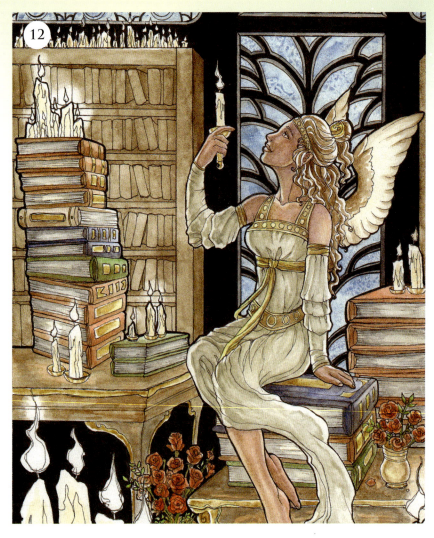

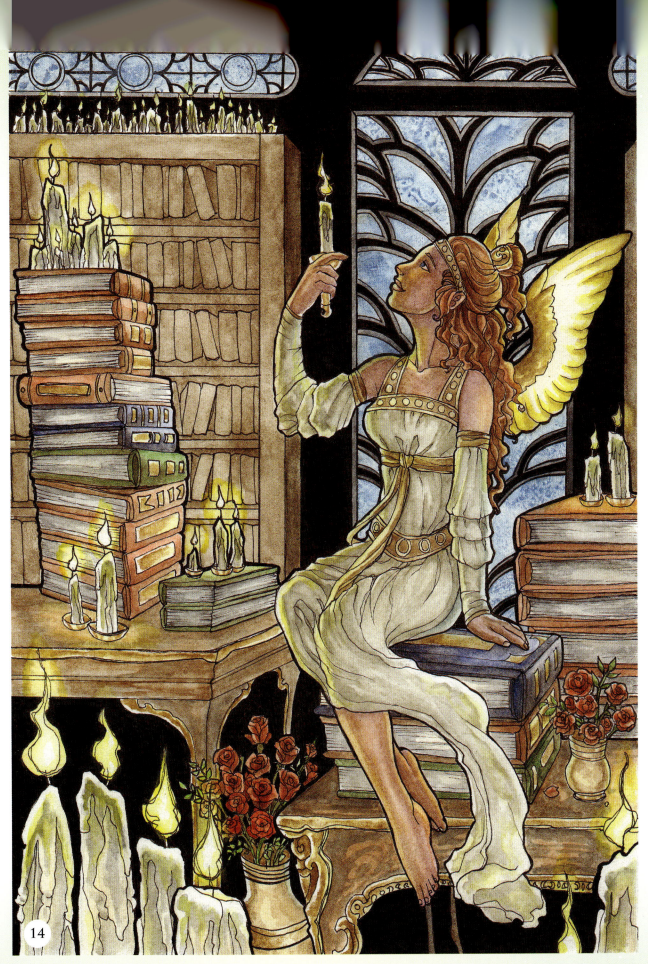

14

THE GUARDIANS:
A DEMONSTRATION IN WATERCOLOR
BUTTERFLY GUARDIAN

Do not fear the wideness of the world, for even o'er the tiniest creatures, there resides an angel. Even for the fleeting butterflies, whose lives are mere breaths in eternity, a guardian lingers.

MATERIALS

WATERCOLOR PIGMENTS

Burnt Umber, Cadmium Red, Cadmium Yellow, Cerulean Blue, Chinese White, Cobalt Blue, Lamp Black, Naples Yellow, Payne's Gray, Prussian Blue, Rose Madder, Sap Green, Ultramarine Blue, Ultramarine Violet, Viridian, Yellow Ochre

OTHER SUPPLIES

nos. 18/0, 00, 2 and 6 rounds

White gel pen

White gouache

1 Apply the Background Wash
Once your sketch is complete, apply a wash of Ultramarine Violet and Burnt Umber into the background stone using a no. 6 round. Don't worry about being neat. The rougher your wash, the more texture your stone will have. For a warmer colored stone, use more Burnt Umber in the mixture.

2 Add Shadows and Cracks
Add shadow and depth to the stone using a no. 00 round and a concentrated mixture of Burnt Umber and Ultramarine Violet. Leave a lip of highlight around the edges of cracks and raised surfaces to give the stone more dimension.

Use a no. 18/0 round to define the cracks and raised edges with a thin line of Lamp Black. The cracks and shadows darken toward the edge of the picture, creating a halo effect around the angel.

3 Lay In the Wing Basecoat
Working background to foreground, begin filling in the wings. Use a no. 6 round to lay in Cobalt Blue and Cadmium Red. For color variation and an iridescent quality, add a hint of Sap Green in the top portion of the blue sections.

4 Develop the Wing Texture
Because the wings are actually feathered, they require more texture than simple butterfly wings. Hint at the edges and spines of the feathers using a no. 18/0 round and a concentrated mix of Cadmium Red for the red sections, Prussian Blue for the blue sections, and Viridian for the green sec-

tions. Add a ring of shadow around the round spots to emulate butterfly wings.

Using a no. 2 round, add more subtle color shifts in the feathers to suggest iridescence; place a touch of Sap Green in the blue sections and a touch of Cadmium Yellow in the red sections.

5 Finish the Wings
Add the black borders and carefully outline the white spots on the wings using a no. 00 round and Lamp Black. If you accidentally fill in any white spots, simply dab them in with a white gel pen.

1

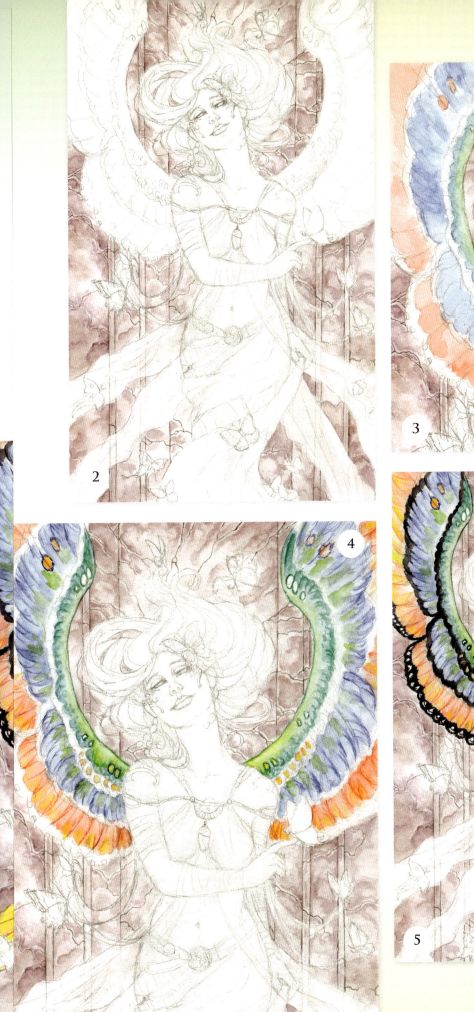

2

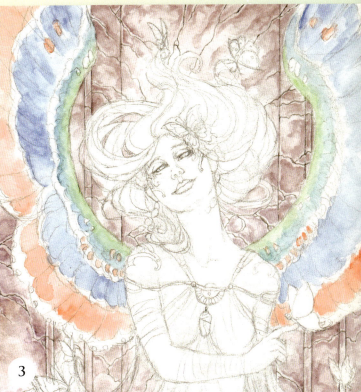

3

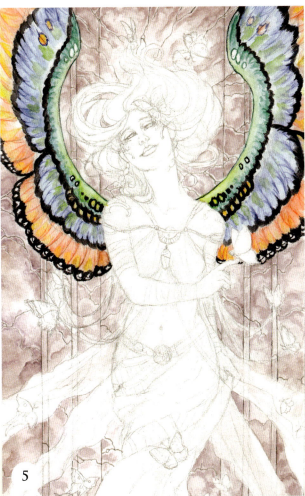

4

5

12 Add Shadows on the Wrapped Skirt

Using a no. 2 round, add light washes of Sap Green and Cerulean Blue to the shadows of the white wrapped skirt. Bring out the detail in her silk arm bands with a no. 18/0 round and concentrated Payne's Gray. Use a stippling of dots near the highlights on the strand to imply a shining texture in the filaments.

13 Begin Coloring the Jewels

Add the shadow color to the jewelry on her belt and necklace using a no. 00 round and Burnt Umber. Again, use dry-brushed textures to imply the strong contrasts of a reflective surface. Then, layer Cadmium Red over the jewelry with nos. 00 and 18/0 rounds, leaving strong white highlights.

14 Outline and Refine the Jewels

Alternating between nos. 00 and 18/0 rounds where necessary, outline the strands of the jewelry with Lamp Black, leaving white highlights to give the jewels more sheen. If you happen to cover up a highlight, or a highlight isn't bright enough, go back over it with a white gel pen.

Using a no. 2 round, add light washes of Cerulean Blue around the butterflies and the cocoon in her necklace to suggest a soft blue glow. Pull the color outward with a clean damp brush to blend the halos into the background area. If you want to strengthen the intensity of the halos, continue swiping with a damp brush until you've lifted out the color from underneath. Then, layer on more Cerulean Blue.

15 Add Finishing Touches

Detail the ghostly butterflies with a no. 18/0 round and Cobalt Blue. Add hints of texture to their wings by using a mix of stippling and light, feathery lines. Accentuate the glow of the cocoon in her necklace with touches of white gouache, being careful not to obscure the outlines of the cocoon itself.

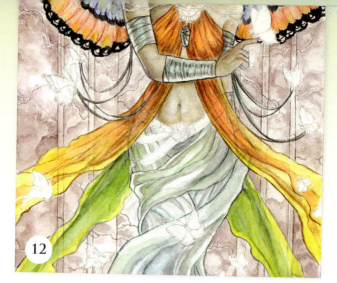

12

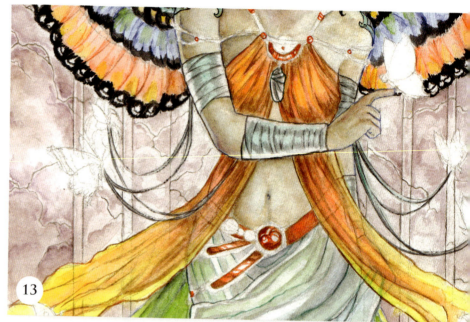

13

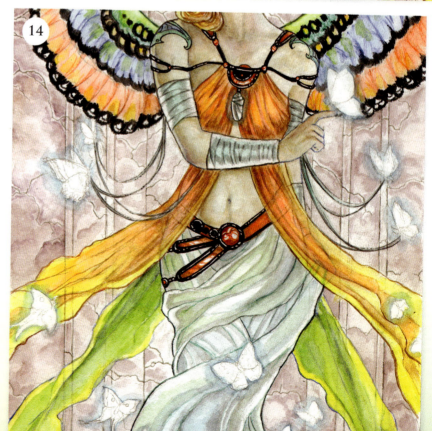

14

94

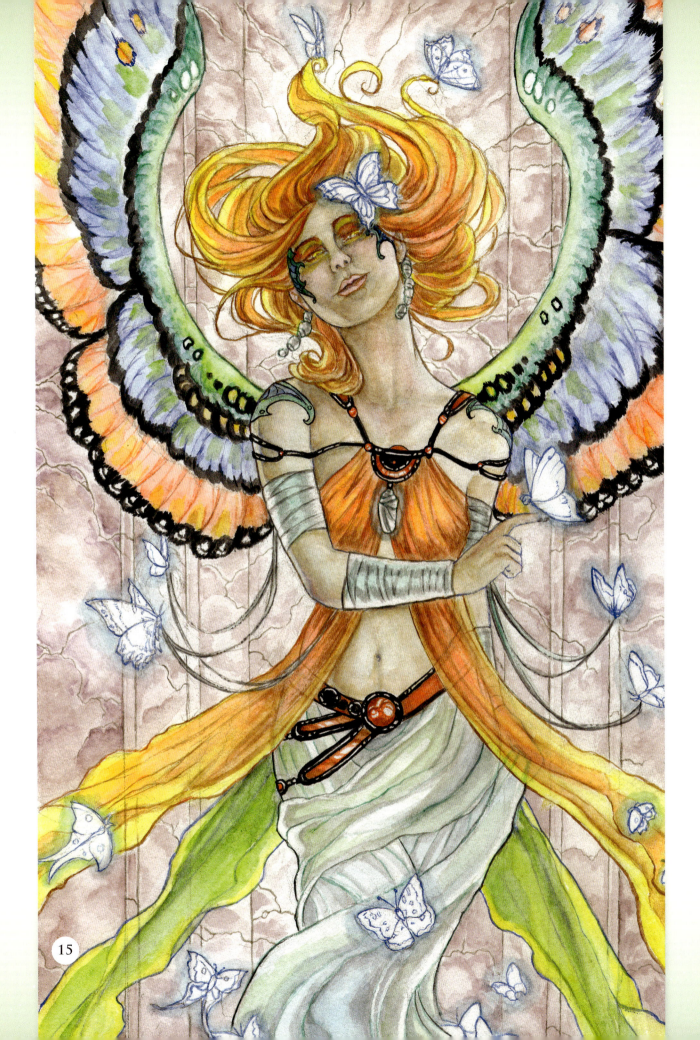

6 Apply Basecoats to the Angel's Skin, Hair and Armor

Using a no. 2 round, lay in a basecoat of Ultramarine Blue to the angel's skin, a basecoat of Naples Yellow to his hair, and touches of Indigo to suggest the shadows in his leather armor. Be sure to drybrush rough strokes in the leather to suggest its cracked organic texture.

7 Paint the Angel's Clothing

Color in the first layer of the angel's clothing using a no. 2 round and Ultramarine Violet. Because his clothing will be white, it should pick up the light and color around it. As such, it will need more than black and gray details to make it appear convincing.

8 Refine the Angel's Skin Tone

Apply a mixture of Yellow Ochre, Cadmium Red and Chinese White to the angel's skin using a no. 2 round. While the paint is still wet, add a blush to the knees, elbows, fingers, nose, toes, lips and cheeks using a no. 00 round and Rose Madder.

9 Finish the Angel

Detail the angel's hair and skin using a no. 18/0 round and Burnt Umber. Drybrush linear details in the hair with light feathery strokes to give the illusion that it is made up of many strands. Add touches of Burnt Umber in the deepest shadows of the skin to define the angel's muscles. Define his tattoo with Cerulean Blue.

Add layers of definition to the angel's clothing using a no. 00 round and a mixture of Cobalt Blue and Ultramarine Violet. Define the shadows with Payne's Gray, and use Payne's Gray and Ivory Black to define the wrappings around the angel's legs. Layer Sepia over the leather bracers until the Indigo and brown tones are blended well.

Outline the angel's clothing and leather accessories with a no. 18/0 round and Payne's Gray. Add a hint of Cerulean Blue to give his eyes an inhuman glow. Paint his brooch with a no. 10/0 round and a base tone of Lemon Yellow and Burnt Sienna.

10 Place Accents and Shadows on the Female Figure's Skin

Add the blush to the female figure's skin using a no. 00 round and Rose Madder. Place a hint of Cerulean Blue on her eyelids to suggest depth. Then, lay in the main shadows of her skin using Ultramarine Violet.

11 Develop the Female Figure's Skin Tone

Because we want the woman to be darker skinned than the angel, use a flesh tone mixture of Yellow Ochre and Cadmium Red without the Chinese White. This results in tanner skin, especially when you layer your washes to deepen the skin's intensity.

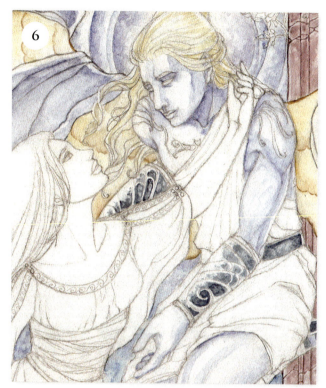

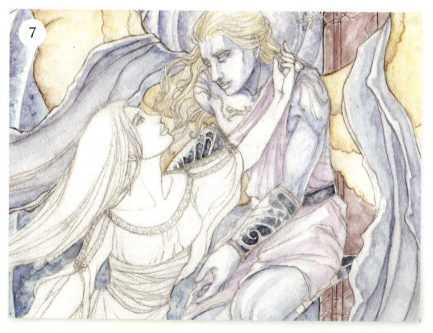

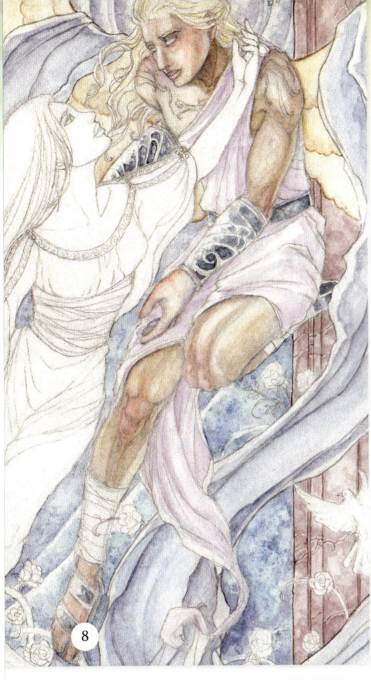

8

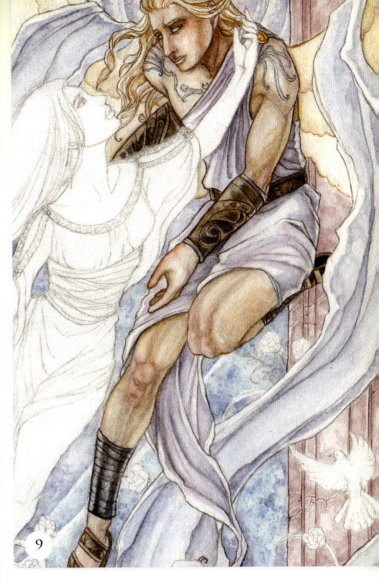

9

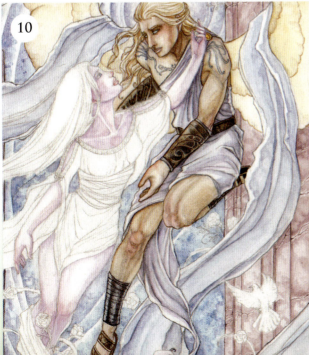

10

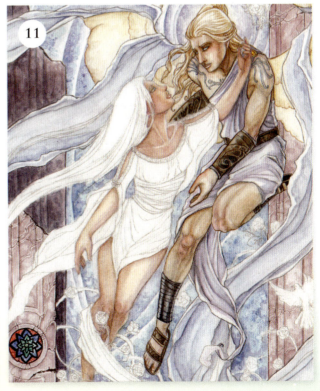

11

A DEMONSTRATION IN WATERCOLOR AND COLORED PENCIL

NIGHT BLOOMING

His prey is but a whisper in the night, an old evil in an old land. But the scene is a familiar one, with the backdrop of night-blooming flowers guiding the hunter along his path. Only they can tell him the secrets of what lies beyond their reach.

For this demo, you'll be using mixed media to help add a grittier feel to the dark angel. While watercolor is light and airy, the heavy texture of colored pencil is effective for rendering scenes that require rough textures and darker tones.

1 Outline the Major Shapes
Outline the main elements of your sketch in colored pencil. Use Tuscan Red for the hair; Black for the background buildings; Indigo Blue for the wings, tattoos and scarf; Marine Green for the flower stems; and Dark Umber for the flowers. Outline the remaining elements in Black as you see fit. This outline will help keep your lines legible as you add watercolor. It also creates a nice subtle texture.

2 Lay the Primary Washes
Using a no. 5 round and a mixture of Cobalt Blue and Indigo, fill in the sky with a mottled wash. Layer the wash more thickly at the top of the painting, and suggest clouds by leaving their pale silhouettes in the sky. Fill in the towers using a no. 2 round and Indigo, leaving them indistinct to indicate that they are in the distance.

Lay a light wash in the foreground using your 1-inch (25mm) flat and Cerulean Blue, leaving a halo of white around the blooms to give them a pale glow.

Fill in the buildings in the middle ground using nos. 2 and 5 rounds and Payne's Gray. Because of the backlighting, these buildings are in silhouette, so don't worry too much about adding detail to their crevices.

3 Establish the Foreground Color
Apply a wash of Sap Green to the foreground, alternating between nos. 8 and 5 rounds to get into tightly detailed areas between the flowers. Use the same brushes and a mixture of Ultramarine Violet and Sap Green to add darker shadows behind the figure. Fill in the dirt path using a no. 2 round and Burnt Sienna.

4 Detail the Grass and Foliage
Add more detail to the grass and bushes with a concentrated mixture of Sap Green using nos. 0 and 10/0 rounds. Accentuate the random shapes within the paint to give the grass an organic feel. Continue detailing the dirt path using the same brushes and Burnt Umber.

Using a no. 0 round, place hints of Cerulean Blue on the edges of the flower petals and fill in the stems with Green Earth Hue. Using a different green for the stems and leaves helps the flowers stand out from the mass of grass.

5 Add Shadow Colors on the Figure
Lay in the shadows on the figure's leather pants, gloves and forearm guards using no. 0 round and Payne's Gray. Alternating between nos. 1 and 0 rounds, add the shadows to his tattered ninja scarf with Burnt Umber, making

the shadows mottled to emphasize the crinkled texture of the material.

Place shadows on his skin and the wrappings of his legs using a no. 1 round and Ultramarine Blue. This adds a cold blue hue to his skin and clothing, ensuring that the warm colors won't overpower the picture.

Alternating between nos. 0 and 1 rounds, fill in the feathery bits with Burnt Umber, and color the leather skin of his wings, as well as his hair, eyelashes and eyebrows with Perylene Maroon. These watercolor washes will act as a guide for later applications of colored pencil.

MATERIALS

WATERCOLOR PIGMENTS

Burnt Sienna, Burnt Umber, Cerulean Blue, Cobalt Blue, Green Earth Hue, Indigo, Lamp Black, Payne's Gray, Perylene Maroon, Prussian Blue, Sap Green, Ultramarine Blue, Ultramarine Violet

COLORED PENCILS

Black, Blush Pink, Cloud Blue, Crimson Red, Dark Green, Dark Umber, French Grey 70%, Grass Green, Henna, Indigo Blue, Light Cerulean Blue, Light Umber, Marine Green, Peach, Pumpkin Orange, True Green, Tuscan Red, White

OTHER SUPPLIES

1-inch (25mm) flat

Colorless blender

nos. 10/0, 0, 1, 2, 5 and 8 rounds

Pencil

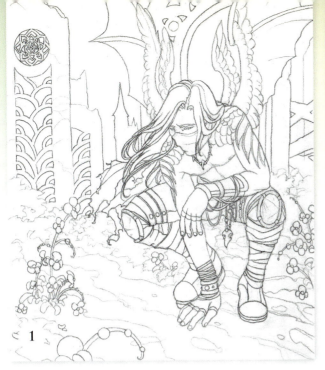

1

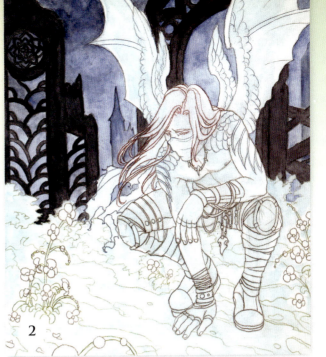

2

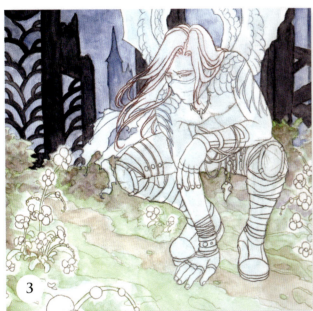

3

4

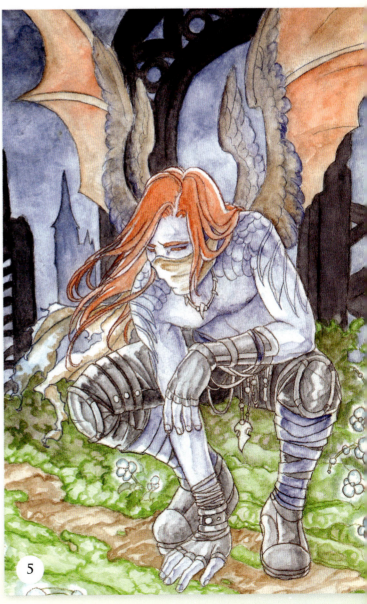

5

6 Refine the Clothing
Using a no. 1 round, layer successive washes of Prussian Blue and Ultramarine Violet in the scarf until you achieve the desired blending and darkness. Fill in the pants, boots and other leather items of clothing with a no. 2 round and Burnt Sienna, mottling the shadows to suggest the texture of leather. Using a no. 1 round, add a layer of Payne's Gray to the leg wrappings, leaving strong highlights to show their reflectivity.

7 Continue Developing the Foreground Foliage
Pop the flowers out from beneath the undergrowth, applying washes of Sap Green and Perylene Maroon with a no. 5 round. Drybrush details into the grass and outline the main shapes with the same brush and a concentrated mixture of Sap Green and Ultramarine Blue. Continue adding deeper shadows into key areas of the foliage and the black wrappings on the figure using a no. 2 round and Lamp Black.

8 Add Blush Tones to the Skin
Switch to colored pencils. To keep the angel from looking too much like a subterranean creature, add Blush Pink to his cheeks, fingertips, elbows and knuckles. Place hints of Henna where you want a deeper, darker blush in the skin. Use a very light layering of Pumpkin Orange on his shoulders and forehead to hint at sun exposure. Even someone like a night angel is bound to have seen the sun at some point!

Add the shadows with very light successive layers of French Grey 70%. If the shadows look too dark, don't worry—these layers will lose some of their distinct edges and color contrast as more layers are added on top.

9 Layer the Skin With Peach
Color the midtones of the angel's skin with light layers of Peach. Don't go too heavy with the layering, or you'll lose the delicate, fair skin you're aiming for with this night angel. Also add hints of the blue reflected light in key areas using Light Cerulean Blue.

By now, you'll notice you're starting to lose the strong detail of the tattoos. Don't worry—these will be brought back later.

10 Complete the Skin
Blend the colors in the skin, burnishing with Cloud Blue until smooth. Burnish with White in those areas where the lightest highlights fall.

Next, redefine the edges of the figure's skin, outlining the main shapes and accentuating the deepest shadows with Dark Umber. Trace over the faint lines of the tattoo as well, using Indigo to bring the tattoo back to the front.

11 Define the Hair and Wings
Apply light layers of Tuscan Red in the hair, eyelashes, eyebrows and wing leather, and layers of Light Umber in the feathered wing sections.

Keep pushing the shadow tones and texture in the wings and hair, adding successive layers of Tuscan Red and Dark Umber to achieve the desired darkness. Also add hints of Black in the deepest shadows of the hair and feathers.

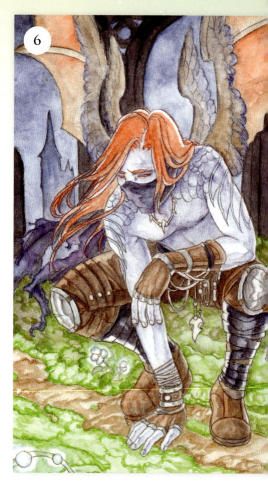

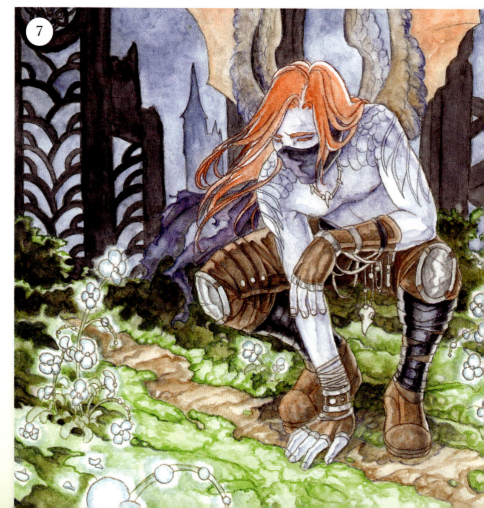

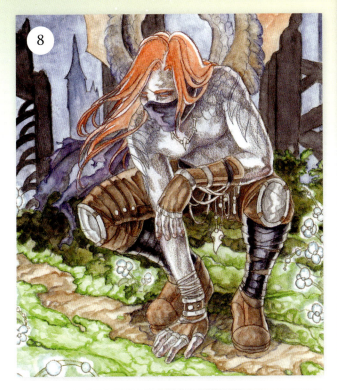

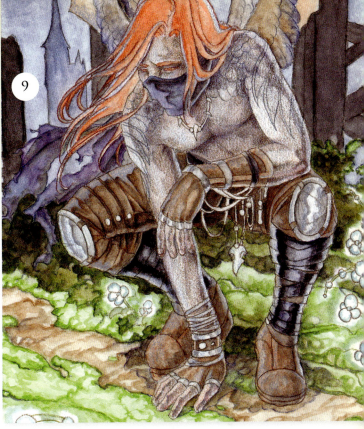

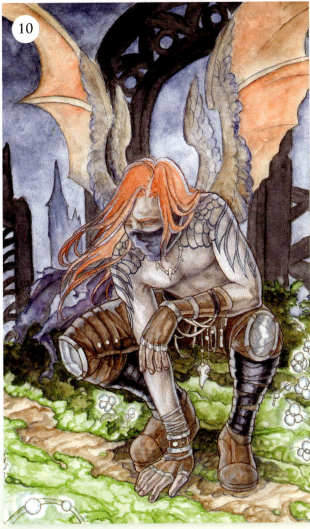

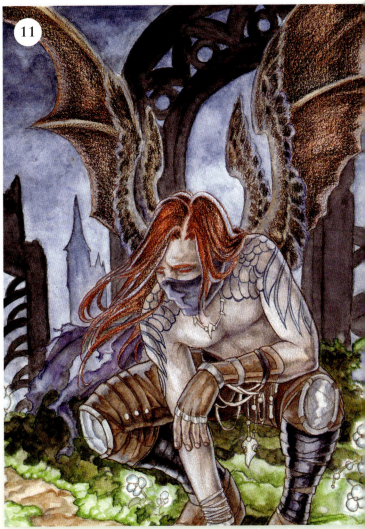

12 Finalize Shadows on the Wings and Hair

Apply more layers of Black to the entire area of the leather wings. Once the paper becomes saturated with the waxy colored pencil, it becomes harder to achieve smoother blending, especially with darker colors. So, use a colorless pencil blender to push and break down the colors, smoothing out the shadow tones in the hair and wings. Don't press too hard with the blender or you could damage the paper by impressing your strokes into it. Notice the blender also shows the direction of your pencil strokes, so keep this in mind as you accentuate the contours of the wings.

Pop out the main shapes in the hair and wings and add more volume using Black. Add wispy strands in the hair mass and hint at the fluffiness of the feathers with hatching.

13 Color the Flowers

Layer Grass Green into the flower stems, burnishing the highlights with True Green. Accentuate the shapes of the stems with Dark Green.

14 Fill In the Jewelry

Color the hanging jewels with Crimson Red, the bones with Light Umber, and the strings with Black, blending them all with White and Cloud Blue.

15 Add Finishing Touches

Darken the path of grass behind the flowers in the bottom left corner using a no. 5 round and a wash of Sap Green and Perylene Maroon. Accentuate the glow of the blooms by adding a rim of Cerulean Blue to their halos of light with a no. 1 round. Finally, emphasize the tattoo with thicker lines of Indigo Blue.

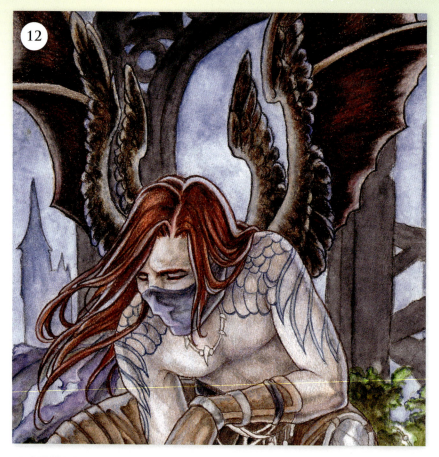

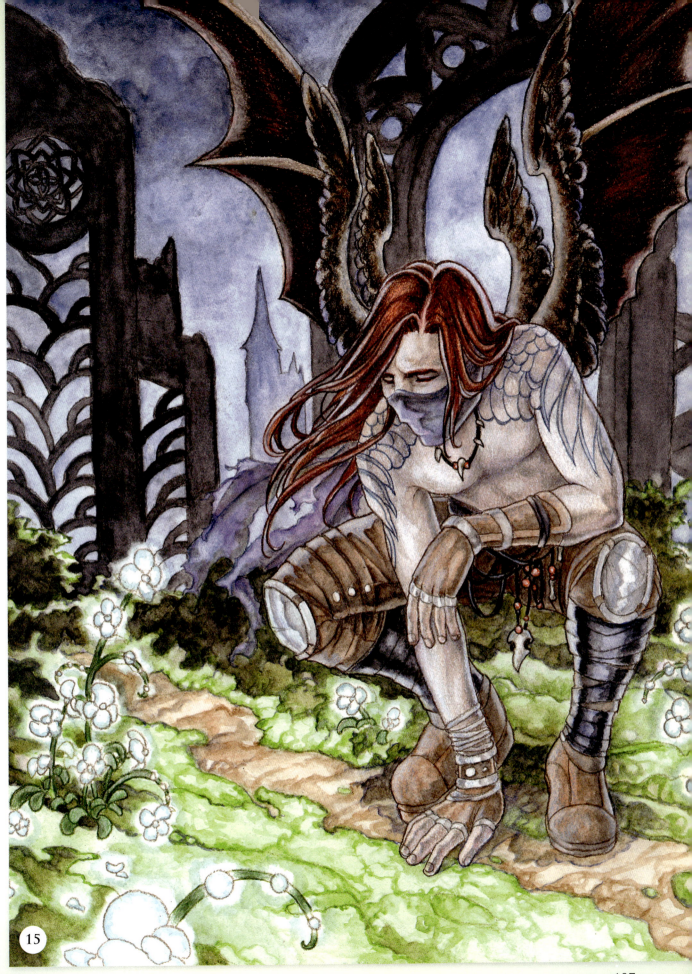

15

7 Color the Hair

Using a no. 2 round, add light washes of Payne's Gray to the figure's hair, pulling your brush in the direction of the hair's movement. Be careful not to go too dark with Payne's Gray, or she'll end up with gray or black hair instead of the shiny silvery-white you're aiming for. Lay in light washes of Intense Manganese with a no. 1 round to bring in the reflected blue light from the background.

8 Add Hair Details

Continue detailing the hair with a no. 1 round and increasingly concentrated washes of Payne's Gray, drybrushing light contours of strands in the hair. Remember to allow some strands to overlap others to give the hair a flowing, voluminous feel. Once dry, lay in the darker details, drybrushing outlines for the barrettes and outer contours with a no. 18/0 round and Payne's Gray.

9 Place Shadows on the Wings

Begin adding shadows to the wings with a no. 1 round and Burnt Umber, accentuating the major planes of the feathers. The yellow tone of Burnt Umber will balance out the deeper purple shadows that will be added later and also keep the shadows from looking flat and lifeless.

10 Deepen the Feather Color

Using a no. 1 round, continue to deepen the purple feathers by applying successive washes of Dioxazine Violet until the brown underpainting is blended to your satisfaction.

11 Detail the Feathers

Using a no. 18/0 round and Burnt Umber, outline the off-white feathers. Use the same brush and a mixture of Burnt Umber and Dioxazine Violet to outline the purple feathers. Remember to add breaks and hatch marks to the feathers to prevent them from looking like solid scales. Unless this angel preens her wings every 2.5 seconds, she's going to have some breaks in her feathers!

Suggest the textured highlights on the purple feathers using a no. 18/0 round and drops of white gouache.

110

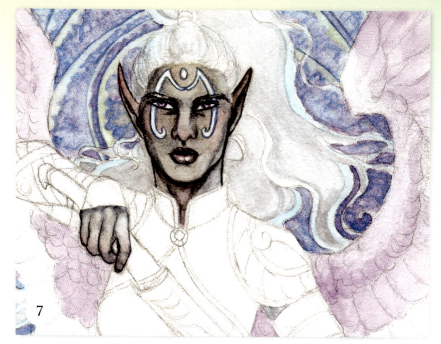

7

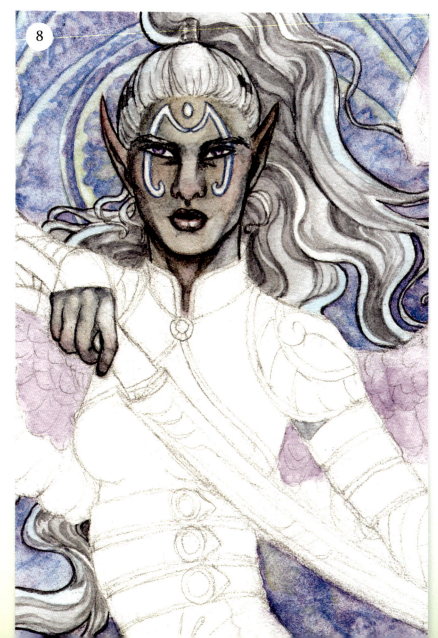

8

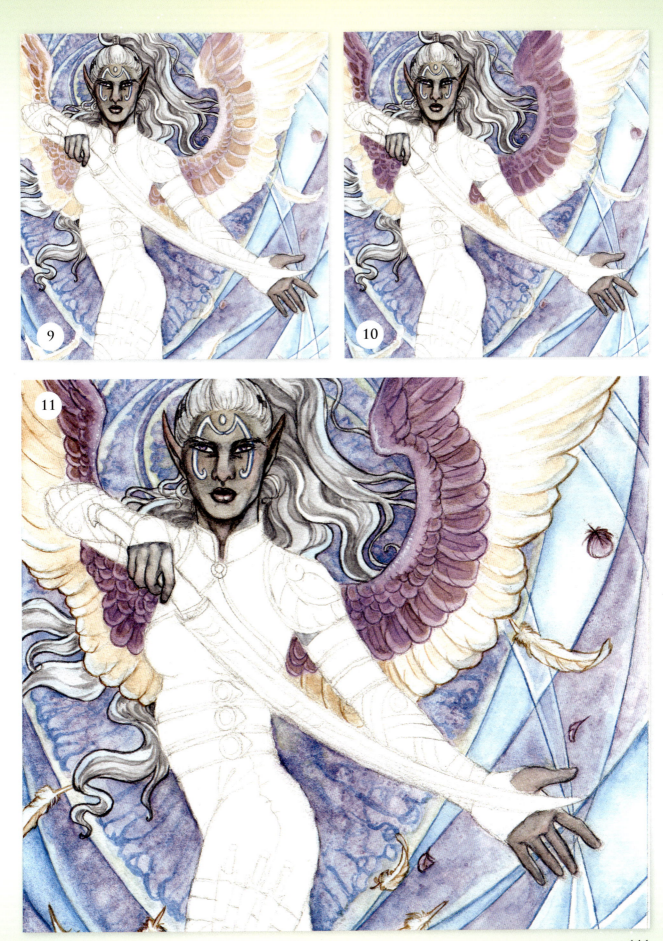

6 Lay In the Basecoat for the Skin

Using a no. 1 round, add a tinge of Cerulean Blue to the angel's eyelids and traces of Rose Madder to his ears, cheeks, nose and lips. Apply a light dusting of color on the muscles of his throat using the same brush and more Rose Madder.

7 Build Up the Shadows

Add the shadow tint to the skin using a no. 1 round and Ultramarine Violet. Because the light is coming strongly from the left, set off the planes of his cheek and nose with a strong highlight.

8 Apply Midtone Color

Using a no. 2 round, apply the midtone color to the skin with a diluted mixture of Yellow Ochre, Cadmium Red and a dab of Chinese White. Use a no. 1 round and Burnt Umber to accent the deepest shadows, peaks and crevices of the skin. If you're not satisfied with the smoothness of the skin tones, add a very diluted layer of Naples Yellow to help even out the tones and deepen the color.

9 Paint the Hair

To create the bluish black color for the hair, first lay in a wash of Indigo using a no. 2 round. Then, add shadow tones using a no. 1 round and a concentrated mixture of Payne's Gray, accentuating the wavy contours of the hair.

10 Begin the Armor and Sword

Paint the metallic gold of his gilded sword and armor using a no. 1 round and Burnt Sienna, drybrushing in metallic contours that emphasize the planes of his weapon and armor. Soften the edges of these contours with a clean damp brush, creating a soft gradient where you want less defined shadows. Finish off the gold armor by applying a glaze of Raw Sienna with a no. 2 round.

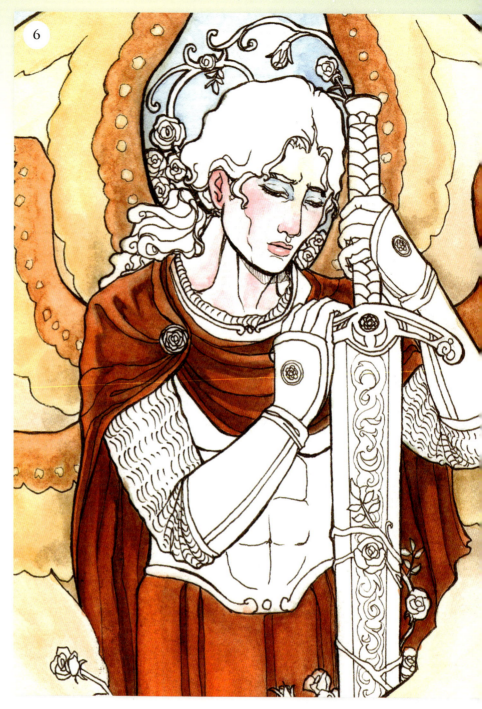

6

CREATING A STAINED GLASS EFFECT

Combining clean ink lines with simplified washes of color creates a mood similar to stained glass. The inked lines in this demonstration are what define the details; the color is merely there to set the mood and emphasize important elements. Too much color detail would overpower the lines, so be mindful of how dark your colors become. Try different colored inks for an interesting effect, though be sure to test your inks first to make sure they are waterproof and won't bleed when paints are applied.

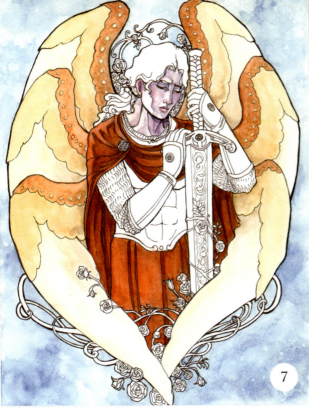

7

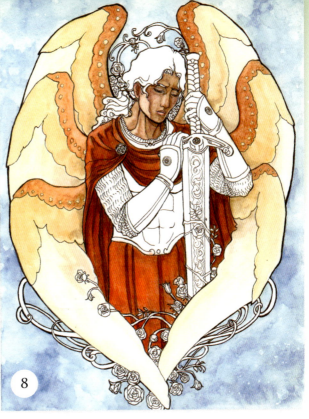

8

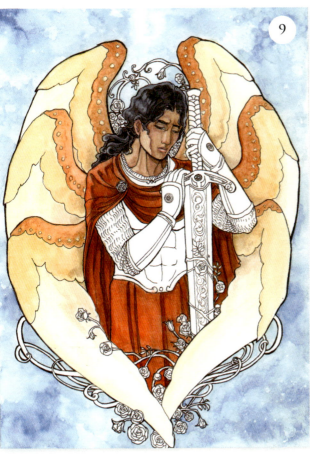

9

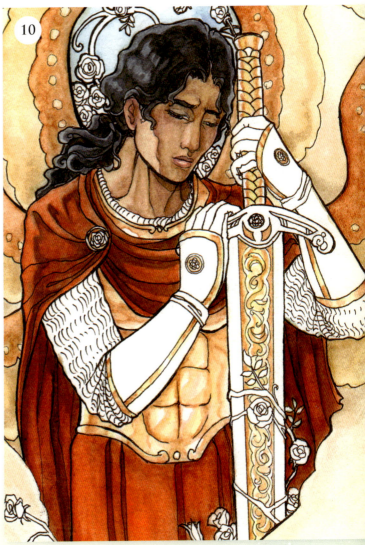

10

12 Begin Coloring the Skin

Add the skin undertones with your colored pencils, using Light Cerulean Blue around the eyes and a grayish pink like Pink Rose for the cheeks, lips, ears, fingertips and elbows. Be sure to use a muted blush instead of a reddish blush to make the angel look inhuman or almost undead.

13 Indicate the Shadows on the Skin

Start building up the layers of shadow on the skin with Cool Grey 50%, adding a touch of Dark Umber into the deepest shadows for color variation. Add Light Cerulean Blue to the shadows for an eerie blue luminescence.

14 Burnish and Smooth the Colors

Burnish the highlights on the skin with White and smooth the shadows with Cloud Blue. If you start losing shadows in the process, continue layering in Cool Grey 50% and Light Cerulean Blue, then burnish on top. Use a very light hand when applying your layers, or you'll saturate your paper and won't be able to apply any more color.

Outline the details and deep crevices in the skin with Sepia, softening with a colorless blender or burnishing where needed. Also outline the details of his three eyes with Sepia.

15 Finish the Eyes and Color the Hair

Add the final touch on the eyes by burnishing the pupils with Sand to give them a golden glow. Use a tinge of Pumpkin Orange in the pupil of the third eye to tie it in with the eyes on the wings. Accent the highlighted gleams on the eyes by blending with White.

Switch back to watercolor, using a no. 2 round to lay in light washes of Cerulean Blue into the figure's hair. Leave strong highlights to give the hair its glimmering look. Deepen the shadows

in the hair using a no. 1 round and a mixture of Payne's Gray and Cerulean Blue.

16 Add Finishing Touches

Add a subtle blue glow to the highlights of the figure's clothing, skin and wings using a no. 2 round and Cerulean Blue. Redefine any lines that may have gotten lost or lightened using your colored pencils.

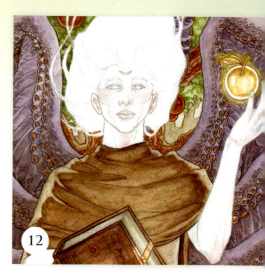

12

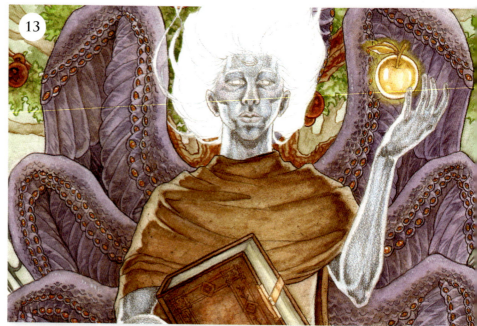

13

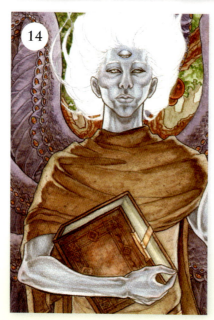

14

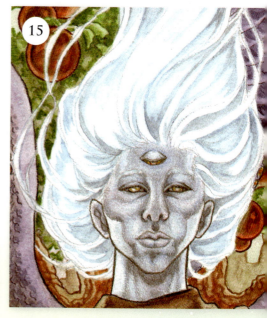

15

16

IDEAS. INSTRUCTION. INSPIRATION.

Angels, faeries and mermaids have engaged the imaginations and enchanted the brushes of artists for centuries. Now you can evoke the spirit of these mystical creatures and create fantastic worlds of ethereal art in watercolor. Step by inspired step, Stephanie Pui-Mun Law shows you how to create the otherworld's most marvelous creatures in exquisite settings.

ISBN-13: 978-1-58180-964-0 •
ISBN-10: 1-58180-964-6 • #Z0688 •
PAPERBACK • 176 PAGES

Lee Hammond demonstrates how to achieve lifelike portraits through smooth blending and gradual tonal changes. She shows you how to create subtle gradation changes and shading of a sphere for more realism in your drawings. Learn what tools to use and how to get the best results from them.

ISBN-13: 978-1-60061-816-1 •
ISBN-10: 1-60061-816-2 • #Z5347 •
DVD RUNNING TIME: 90 MINUTES

Watercolor Artist celebrates the magic of watercolor with columns and features from the top watercolorists working today. A magazine for watercolor painters and illustrators, *Watercolor Artist* features practical, step-by-step instructions, new product information, artist profiles, and answers to readers' questions about technique.

FIND THE LATEST ISSUES OF
WATERCOLOR ARTIST
ON NEWSSTANDS, OR VISIT
WWW.ARTISTSNETWORK.COM.

IMPACT-Books.com

- Connect with other artists

- Get the latest in comic, fantasy, and sci-fi art

- Special deals on your favorite artists

These and other fine **IMPACT** products are available at your local art & craft retailer, bookstore or online supplier or visit our website at www.impact-books.com.